JUDY DATER
TWENTY YEARS

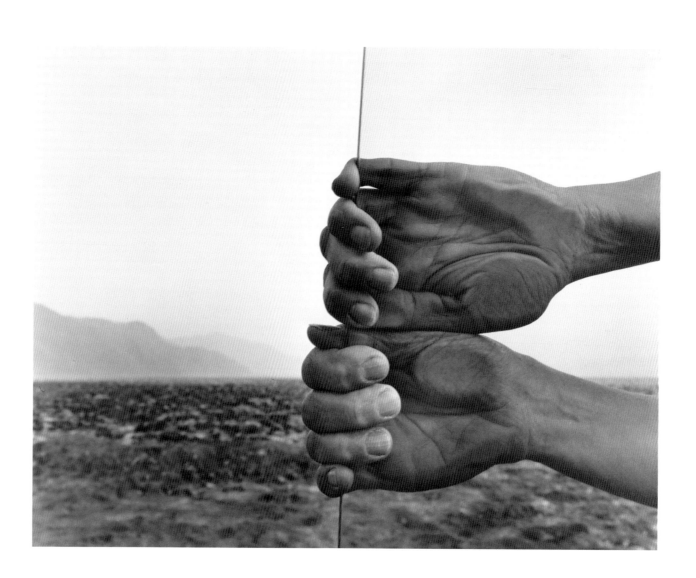

JUDY DATER
TWENTY YEARS

with an introduction by JAMES L. ENYEART

THE UNIVERSITY OF ARIZONA PRESS
in association with THE DE SAISSET MUSEUM, University of Santa Clara

ABOUT THE AUTHOR

James L. Enyeart has studied and written about contemporary photography since the mid-1960s. Since 1977 he has been director of the Center for Creative Photography at the University of Arizona. The recipient of a number of grants from the National Endowment for the Arts and other agencies, he has published many articles on modern photographers as well as the book *Edward Weston's California Landscapes*, and has edited *The Archive* since 1978.

Publication of this book is made possible in part by a grant from the National Endowment for the Arts.

THE UNIVERSITY OF ARIZONA PRESS

This book was set in VIP Melior types.
Manufactured in the U.S.A.

Library of Congress Cataloging-in-Publication Data

Dater, Judy.
Judy Dater, twenty years.

Bibliography: p.
1. Photography, Artistic. 2. Dater, Judy.
I. Enyeart, James. II. Title.
TR654.D338 1986 779′.092′4 86-1363
ISBN 0-8165-0954-9 (alk. paper)

FOR SAM

CONTENTS

ACKNOWLEDGMENTS

This monograph on the photographs of Judy Dater has been published in conjunction with a twenty-year survey exhibition curated by James Enyeart for the de Saisset Museum, University of Santa Clara. Partial funding for the exhibition and for this publication has been provided by the National Endowment for the Arts.

I would like to thank and acknowledge James Enyeart for his thoughtful essay which accompanies this volume and for his insight and expertise as curator of *Judy Dater: Twenty Years*. We are also grateful to Mr. Enyeart, who, as director of the Center for Creative Photography, arranged for the loan of photographs from the Center's permanent collection and for an exhibition at the University of Arizona. I also thank Seattle collector and photographer Wah Lui, who has generously loaned photographs from his collection to be included in the exhibition.

The Art Museum Association of America arranged for the exhibition to tour nationally. In particular, I am grateful to Harold Nelson and his staff in the exhibitions department of the AMA for their efforts in coordinating the tour.

Finally, I would like to extend my gratitude to Judy Dater for her patience and cooperation throughout this three-year effort. I am proud to have had the opportunity to present her outstanding and powerful images to a wider public.

Georgianna M. Lagoria
DIRECTOR
DE SAISSET MUSEUM,
UNIVERSITY OF SANTA CLARA,
CALIFORNIA

JUDY DATER: TWENTY YEARS

WORKS of art are capable of compressing into visual form a greater variety of intellectual and emotional experiences than is readily understood or described by our other senses. Perhaps that is why so little that is written about art truly reveals more than can be realized by even the untrained eye. Words are, at best, ambient reflections of what we see. Nevertheless, the power of written description can unlock a wealth of stored metaphors, memories, and history that give confidence to our vision and reveal the intimate nature of the aesthetic experience.

This book of Judy Dater's photographs, covering the period from 1964 to 1985, represents the most complete body of her work that the public has had an opportunity to view. The photographs have been selected to reflect the evolution of her work during this time. The intent of the essay is to provide an appreciation for the range of her work and through Dater's own comments to reveal the personal experience that guided her in giving the photographs a life of their own.

Revelation, confrontation, and empathy are the dominant qualities of Dater's work. She refers to the process of imbuing her photographs with these qualities as "working with feeling." Her photography is a public manifestation of her thoughts and emotions. The thread that runs through all of her work is the intermingling of her own personal mysteries with provocative subjects and their psychological presence. The critic Joan Murray wrote that Dater's work can be ". . . coldly objective and spontaneously subjective. There is a chameleon quality to Dater, both in personality and in the work she produces. Who she really is may be her secret." [1] This chameleon quality reflects the way Dater is able to immerse herself in the personalities of her subjects without losing the essential control incumbent upon the artist.

Dater was born in Hollywood, California, on June 21, 1941. Her childhood and adolescence were essentially middle class, filled with secure family relationships

and an unusual sensitivity to her own emotional posture in the world. Her father owned and operated a movie theater where her appetite for romance and individuality was stimulated by a universe of unique characters. The faces, gestures, dress, and expressions of the celluloid personalities revealed—or betrayed—their innermost identities. She carried with her into adulthood this fascination with extreme personalities and expression of extreme emotions that could conquer the dull and ordinary in life. Overcoming the ordinary, she also found a way of aesthetically exploiting her own emotions. By the time Dater was ready for college, her earlier intrigue with movies had matured into a drive to create objects and ideas of her own. She enrolled as a student in drawing and painting in 1959 at U.C.L.A. and transferred in 1962 to San Francisco State, graduating in 1966 with an M.A. in photography. While a student at San Francisco State, she studied under Jack Welpott. They were married in 1971 and, before they were divorced in 1977, collaborated on a project that resulted in a timely book for both of them: *Women and Other Visions* (New York: Morgan and Morgan, 1975).

Dater and Welpott each photographed women, sometimes the same women, from a personal perspective. The subjects they chose represented a broad cross-section of individuals with widely differing lifestyles. Among their subjects were women whose personas demanded representation through facial portraits, others who reflected the tenor of the 1970s in their dress and manner, and some whose sexuality was foremost, in varying degrees of subtlety or bluntness. Yet, in all the photographs, it was the difference between Dater's and Welpott's styles that made the project successful. It was in their semi-nude and nude photographs that this difference became the most apparent. The women reacted visibly to each artist, sharing different aspects of their characters with Welpott, the man, and Dater, the woman.

Posed before Dater's lens, the women seemed to reach inside themselves and bring to the surface their feelings and concerns as women. Because Dater could 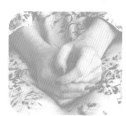 identify with these characteristics and desires, she was able to apprehend the very moment when truest representation of each subject's inner psyche was the most evident. Dater used the women's wardrobes and living environments as a means of enhancing and emphasizing the spirit of their self-realization.

Her sense of timing gave new meaning to the concept of a "decisive moment" in photography. She had not caught some event of life in chance perfection, but had selected the time, place, and instant when revelation of the mind was made known through a person's physical being. Her concentration on facial expressions and body language demanded that the camera be placed in front of the drama before her. The subject could then be recorded as a free-floating yet dominant form in the composition of the environment. Dater's empathy for this critical moment resulted in a special psychological quality in the portraits that has become a hallmark of her style. Her subjects move through the thought process seemingly half-conscious of their bodies, signaling and desiring a dialogue with the viewer.

Welpott's style differed in that the women he photographed reveal a greater awareness of their bodies and the process of interacting with the camera. When

sexuality and sensuality were intended as the dominant issue in his portraits, the women exuded these qualities more as a performance than as a revelation. This could be expected, in part because of the subjects' reactions to a male photographer, but also because Welpott explored each person as the essential dynamics of his own vision. This is not to say that Welpott's photographs are without psychological importance. Rather, it is that the bodily and facial expressions of his subjects suggest that their mental and emotional experience before his camera was more one of projection than of secrets and vulnerability.

Much of the difference between the two styles can be seen in the facial expressions and body language of the subjects as they reacted to what they believed was expected of them by the photographers. There were, of course, similarities: both artists approached their subjects with the assumption that the women possessed unique characteristics which set them apart as individuals. They inspired each other in the search for women who could expand their combined visions of womanhood. At times this closely shared quest for subjects resulted in images that bore visual influences of one artist upon the other.

During the period that Dater and Welpott lived and worked together, this mutual exchange of inspiration and influence had an important impact on both artists. Dater's interest in people inspired Welpott to re-explore in a concentrated way an area of aesthetic interest that had been a part of his concern for years. Welpott, in turn, introduced Dater to a group of artist friends, including Imogen Cunningham, Ansel Adams, Brett Weston, and Wynn Bullock, who had positive and lasting effects on her appreciation of what it meant to be a photographer. She saw first-hand the way they had devoted their lives and energies to photography, and their excellence of craft became a standard by which she could judge her own work.

The use these artists made of large-format cameras, their love of form, and their "straight" aesthetic gave Dater a means of making portraits, like the movies, larger than life. As she grew as an artist the romantic quality of her earliest works, as in *Lovers*, 1964 (page 8), gave way to a leaner sense of design as in her portrait *Joyce Goldstein*, 1969 (page 50), which helped her probe the complex components of human emotions in portraiture.

Dater's first exhibition took place at the Aardvark Gallery and Bindery in San Francisco in January and February of 1964. Twenty years later, she has come to be recognized throughout the United States and Europe for her radically revealing portraits, especially of women. It is a mistaken impression, however, that women subjects dominate her work. She has made about as many portraits of men as of women, and some of her photographs made between 1965 and 1970 were not portraits at all. Likewise, most of her photographs made after 1980 are not strictly portraits but are works portraying herself as a variety of archetypical subjects. These photographs are intended to be tools more of critical inquiry than of self-revelation. Her best-known images and in some cases her most powerful subjects are nudes, such as *Twinka* (page 43), *Imogene and Twinka* (page 47), and *Nehemiah* (pages 14 and 15). Even though Dater has made fewer nudes than clothed figures, the popular misconception (based on the power of such images as these) that nudes are her

primary subject has caused her to be invited to lead workshops on photographing the nude throughout the United States and Europe.

Dater is partly responsible for the misconception because she accepts the attention that such workshops bring. In addition, Dater's photograph *Twinka,* a veiled nude woman, was reproduced on the cover of *The Woman's Eye* (New York: Knopf, 1973), by Anne Tucker. Of the ten Dater photographs reproduced in the book, 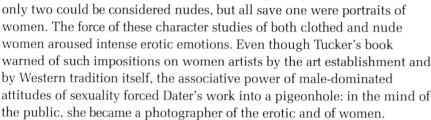 only two could be considered nudes, but all save one were portraits of women. The force of these character studies of both clothed and nude women aroused intense erotic emotions. Even though Tucker's book warned of such impositions on women artists by the art establishment and by Western tradition itself, the associative power of male-dominated attitudes of sexuality forced Dater's work into a pigeonhole: in the mind of the public, she became a photographer of the erotic and of women.

Dater is also categorized as a "portrait photographer"—and this label, too, seems inadequate to describe the intensity and penetration of character revealed by her work. Tucker wrote that Dater considered herself within the tradition of "interpretative portraiture," but that description also fails to convey the strength and consistency of her photographs.[2] Whether the subjects are clothed or not, her photographs are character studies. Dater's archetype studies using herself as the subject are far from mere self-portraits. Altogether, her photographs of herself and of other people reveal character to a depth that surpasses conventional expectations of portraiture.

Dater shares a realm of psychological characterization with such photographers as Diane Arbus, August Sander, and Richard Avedon, despite their obvious differences in style and aesthetic motivation. Even when Dater uses herself as subject, it is the human values of that particular fiction that she is expressing. In one interview, Dater touched on the revelation of character in discussing nudes. She said, "I've never been personally that interested in the nude as abstract form, but in the individual and the possible personality change as I work. People tend to reveal themselves to the camera and express something about themselves, perhaps even something hidden from themselves."[3]

Dater made a lasting impression on New York's art media and consequently on the public in the fall of 1972. She had been invited to show a selection of photographs in the smaller of two exhibition spaces at the Witkin Gallery in New York. A one-person show of photographs by Berenice Abbott was to occupy the larger and more prestigious gallery space. However, just a few weeks before the joint opening, Abbott's show was canceled and Lee Witkin offered the entire gallery to Dater. The photographs that Dater pulled together to fill both galleries relied heavily on her recent portraits of women, and many of those were of nude and partly unclothed figures. These portraits, made between 1969 and 1972, embodied the socio-sexual freedoms aligned with the growing feminist movement.

Commercial photography galleries were just beginning to open in cities across America at this time, and the Witkin Gallery, which had opened in 1969, held a position of interest and acclaim afforded few museums. The New York press and

photography magazines reacted enthusiastically to the exhibition. A. D. Coleman wrote in the *New York Times* (June 4, 1972): "The emotional intensity of the portraits of women is generated by a combination of qualities. One of these is their energy; these images tremble with life. Another is the sexual tension registered within them, which is not at all subliminal but always operative at or near the surface. And a third—probably the most crucial—is the fierceness of their self-assertion; each of these images seems to be a mutually agreed-upon statement, the revelation of a previously hushed secret known only to the photographer and her subjects and now announced as the seal on a pact of blood."

Dater's portraits of herself and other women address issues of universal concern. For her, freedom from the social, political, or sexual oppression of stereotyping is perhaps the most universal need today: to escape being a part of a moral majority, silent minority, or any other form of collective stereotype—to resist being a psychological puppet to a government or to an individual who professes superiority of any kind over another person.

Discussing her work or herself is not a priority of Dater's: "I never liked to overexplain my photography . . . it goes against the way I work, which I think is straight from the heart, gut, and instinct."[4] She is uncomfortable with theorizing about her photography, preferring to discuss what a viewer might gain from seeing one of her images. She moves with fashions of the art world reluctantly, unable to force her work into costumes that might fit each new parade of popularly embraced ideas. The evolution of her work from one series of subjects to another stems from her desire to explore new territory and challenges. She is eager for the public to consider each new idea without comparing it to earlier and different ideas. The public's expectations always lag behind the changes in an artist's work, and that gap has presented artists with a dilemma over the centuries. Eventually, however, on seeing the work of a career over a span of years, the public comes to recognize that, through all their changes, a given artist's works and ideas were cohesive after all.

Time is Dater's greatest ally. She has said, "The older I get, the one thing I can trust in myself more than anything else is the way I feel about something. When I photograph I try to be as aware of my feelings as I can be and to somehow try and get them out of me and onto the film in terms of the way I am responding or seeing the world. I can then sit back and look at the stuff and analyze it in certain objective ways after it's all done and tell whether or not it works graphically. I can tell if it's good technically, but at the moment when I am actually making the picture, all I can go on is my feelings about things."[5]

The fact that Dater photographs people predominantly but cannot be described exclusively as a portrait photographer says more about language limitations than it does about art. We have become so used to labels in the arts that we forget they are artificial means of discussing what artists create without thought of category. Our convenience in language becomes a trap unless we accept the fact that artists must be allowed the freedom to make nameless excursions into as many different realms as their passion demands. The more difficult it is to categorize artists, the more likely

it may be that their contributions will outlive the fashions of the day. What, for example, would one call Lee Friedlander, Harry Callahan, or Imogen Cunningham? They are photographers who defy labeling.

Discussion of art is a way of participating in it and is not to be confused with categorization of artists. As viewers we look for connections between the artist's experience and ours in hope of clarifying our understanding and enhancing our appreciation. (The question of the artist's intent has often led critics and the public astray, since, as has been observed, artists more often know what they are doing than why.) As a way of understanding and appreciating Dater's photography, I suggest that viewers may see revelation in her portraits, confrontation in her nude images, and empathy in her self-portraits.

No one has explained the attraction of Dater's portraits better than herself. In interviews she has said that people reveal themselves to the camera by exposing things that may be hidden even from their own consciousness. But it is not just any camera, it is Dater's camera in particular that is more than a mirror of faces. Where August Sander's portraits collectively reveal the spirit of a whole people (the Weimar Republic), treating single members of the group as details of the environment, Dater's portraits are about the whole of an individual alone. "To me, all the people I photograph are beautiful. I realize that their looks may not fulfill the standard

concept of beauty. I am attracted to them because they have something fascinating about them, a certain flair. They are people who know how to accentuate their strong points. And yet, even this strength of personality is not quite enough to make a good portrait. To be effective, a portrait has to touch the viewer in some way; and it must possess some elements of universal truth as well as graphic appeal."[6] The universal qualities that Dater knows must be there to "touch the viewer" stem from her perceptions of the dominant characteristics of a subject's expression, body language, dress, grooming, and posture before the camera. Dater has said, in fact, that her photographs are about her own emotions, instincts, and intuitions. Can she mean that, when we perceive arrogance, narcissism, or exhibitionism in one of her portraits, we are experiencing the dark side of Dater's own psyche?

Critics have called Dater's photography chameleon-like; and, like a chameleon, whose color changes with its environment, in her portraits Dater becomes absorbed in a psychic environment—she becomes for a moment the person in front of the lens. Dater's ability to bring both her own personal revelation and that of her subject to a portrait demands that she not only be able to distinguish universal meaning in human traits, but that she be able to experience them as well. To portray a particular character convincingly, the actor/artist must become the person and yet retain the audience's faith in her or his actual identity.

Even in sharing the subject's identity, Dater must maintain some distance between herself and the model. She has said, "I like people, I like their faces. I like the way their bodies move. I prefer animation. The photographer needs to establish a bond with the subject, and yet too much intimacy could get troublesome. Once you know a person too well, you come to the session with preconceived ideas. This tends

to get in the way of the photograph."[7] "Most people are friendly, but I still get nervous at the first meeting with the model. If I'm not, it's almost as if something is missing. It's as if there has to be this funny tension between the two of you for the thing to work. Hand movements to me are especially important in revealing personality."[8]

Generally, when Dater discusses her subjects, she does not refer to them as men or women, just as people. The gender question arises only when prompted from the outside. This is because she views sexual expression as just one more distinct characteristic of the person she is photographing. The sensual quality of her nudes, regardless of gender, reinforces this idea. The placement of hands, the twist of a head, the glare or glaze of eyes, and choice of clothes (Dater and her subjects select together what will be worn for a sitting) and how they are worn all move in concert before her camera. "They get into performing, in a sense, for the camera—which is really what I want."[9]

Dater's portraits from trips to Egypt in 1979 and in 1980 represent her first use of color photography. About these portraits Dater has said, "It's odd, but I went over there thinking I probably wouldn't photograph people very much. I didn't know if I could do it there. I imagined I would make dreamy, romantic, mystical, decorative pictures, but not so. Or at least I don't think that these are about that too much. I think some are dealing pretty directly with color, but in general they are about 'feeling.' I think they express my direct experience of encountering Egypt. That whole experience was for me a real yin/yang adventure. Things were either fantastic or awful, fabulous or dull, plush and comfortable or intense discomfort, always hot and always very alive, never, never grey."[10] This work was indeed about the feeling, the revelation, that has always been a part of her photographs, especially her portraits. In the world of sound we believe that some composers hear music in their minds before they write it down. Similarly, for Dater there is a swell of emotions that runs through each photographic experience.

Dater's self-challenge of not working in black-and-white photography was unusual but successful. She accepted color as something she inevitably had to try, not because it was the fashion of the 1970s, but because she had found that working "directly" with color she could attain new levels of character revelation. The photographs she made in Egypt could not have been made in black and white. She found that having been trained in drawing and painting, she could see the image in color as a suitable replacement for the more abstract white-to-black scale of her previous work. She was as comfortable with color as she had ever been in monochrome photographs. It was important to these photographs that she selected and used color as a bridge to larger aesthetic issues and did not become trapped into making prints that were solely about color itself, as have so many photographers.

In 1984 Dater photographed disabled artists for the Institute of Art and Disabilities of Richmond, California. The governor of California had declared the week of October 7−13 as Disabled Artists Week, and the Institute of Art and Disabilities organized a conference cosponsored by the San Francisco Museum of

Modern Art featuring presentations by artists, humanists, philosophers, and art critics. Even though Dater's photographs were done on commission, it was the intent of the Institute to hire Dater as an artist and not as a commercial portraitist. A special exhibition of the portraits was installed at the War Memorial Building.

The particular disabilities of the people were not important to the portraits, nor were they to Dater. It was important to Dater that they were artists or engaged in creative activities when the portraits were made. The emotions of these people were less hidden and at the same time more animated than those of Dater's usual subjects. Through their directness and the directness of Dater's approach (a black backdrop and centered three-quarter-bust composition) these black-and-white portraits are among the strongest of all her photographs. While her other portraits, color and black and white, may be seen as various movements of a symphony, these images are like instrumental solos—solitary and captivating in their simplicity.

These photographs represent and reveal human emotions on a level of aesthetic concern that is as sophisticated as any of Dater's artistic accomplishments. While in her previous portraits Dater allowed the excesses of her subjects to show through, becoming in some cases a revelation of her estimation of that individual, in these images she has distanced herself and the viewer from the intimate lives of the individuals. The environment in each portrait has been blanked out to eliminate unwanted details. It is a simple device that has been used by commercial portrait photographers throughout the history of the medium. However, in traditional portraiture the subject is drained of all but the most superficial of emotional expression in order to present the subject in as flattering a posture as possible. Dater's use of the technique allows emotional gestures to become the dominant visual concern, giving these portraits a sense of humanitarianism that may reflect her own changing interests in the world about her. She seems to have entered a special domain in contemporary art in which the artist does not reflect society, but precipitates society's recognition of itself.

Dater's nudes are the best known and, perhaps, most popular of her portraits. The very success and power of these images demands recognition. Her most popular nudes were made during the mid-sixties when she and most American artists were addressing shifting cultural values. The dominant shift in American values during the 1960s was toward confrontation, a movement toward directness in political, social, and personal issues, and in interpersonal relationships.

About her early work involving female and male nudes, Dater has said, "Usually there was a quality about them that suggested something uniquely contemporary and, of course, there had to be something visually interesting. At the first sitting they would be clothed, [and] doing a nude study was just a natural development. People in the nude have a certain universality that comes out when you take away the clothes. If the subject seemed open to the idea, I suggested it. Sometimes they would suggest it.

"Women photographers interested in doing men have much less to fall back on than men photographing women. That is part of the challenge. Because so few people are doing male nudes, there is more of a chance to do something that hasn't

been done before. There is still a taboo feeling about male nudes, both from publishers and about the showing of them in certain places.

"Usually my ideas come about in just something I sense as the model and I are working. Sometimes an idea has to do simply with the mood of the place. I work so intuitively I may not know what I am doing until I am finished." [11]

Dater's nudes, whether male or female, unclothed or half-clothed, are particular people with their own identities, not generic forms or abstract symbols. They are more sensual than sexual, but always erotic in a personal confrontational manner, that is, personal on the part of the subject. The people look directly at the camera, offering their nudity on a level that confronts the viewer with the naturalness of their state of undress. About these photographs the critic for *Ms. Magazine* (June 1978), Shelly Rice, wrote: "Dater's female subjects are projections of her own personality—vigorous, confident, direct. Unlike the seductive women we are familiar with in advertisements, Dater's sitters are never cuddly, submissive, or coy. They are, in fact, quite brazen about their sexuality."

Many factors, both aesthetic and social, contribute to Dater's use of nudes in this way rather than as classical studies in ideal form. Certainly, erosion of American society's Victorian attitude toward public exposure of the body during the 1960s played an important role. Even if artists do not intentionally reflect their society, they cannot help being influenced by their surroundings. California, in particular, during this decade brought all of its social experimentation to bear on personal freedoms. Traditional values, both social and cultural, were regarded with suspicion as too often imposing an impersonal and manipulative behavioral code upon the individual.

Dater's response to the 1960s was carried into the 1970s and continued to contribute to a style of nude portraiture that was unique, becoming more confrontational as time passed. By 1983, Dater was looking for ways to broaden her audience and to connect with other artists whose ideas she perceived as related to her own. In her lectures she quoted Lucy Lippard's *Overlay: Contemporary Art and the Art of Prehistory*: " . . . women artists' attempt to restore a forceful image is a complex enterprise. Replacing the headless and expressionless nudes, the flowery muses and femmes fatales and bovine comforters of 'high art' history with a new active persona, or trying to imbue the old images with more positive content, is not an easy task." [12]

To contrast Dater's nudes with those in the history of art, we must turn to *The Nude* by Sir Kenneth Clark, published in 1953. The book unfortunately does not contain an informed historical account of women artists or of photography as art, yet it remains the most thorough study of the nude as ideal form throughout the history of western art. It is against the background of the ideas and opinions expressed in Clark's book that we can best understand Dater's use of the nude, through which she confronts her own sexuality and at the same time shows an awareness of the nude as ideal form.

In the chapter titled "The Naked and the Nude," Clark wrote, "Consciously or unconsciously, photographers have usually recognized that in a photograph of the

 nude their real object is not to reproduce the naked body, but to imitate some artist's view of what the naked body should be." [13] This statement, typical of past traditional art historians' views, represents the sort of misunderstanding against which photographers have had to contend. Clark went on to say that the more perfect the model, the greater the failure in photography because it cannot hide the "wrinkles, pouches, and other small imperfections." [14] It is, of course, exactly these details that Dater wishes to apprehend as a part of the personality of her subjects. The ideal body, female or male, of Clark's classical preference was exchanged by the realists (like Dater) of the 1970s for a believably real person.

Clark reaches some common ground, however, on the subject of eroticism: ". . . no nude, however abstract, should fail to arouse in the spectator some vestige of erotic feeling, even though it be only the faintest shadow—and if it does not do so, it is bad art and false morals. The desire to grasp and be united with another human body is so fundamental a part of our nature that our judgement of what is known as 'pure form' is inevitably influenced by it; and one of the difficulties of the nude as a subject for art is that these instincts cannot lie hidden, as they do, for example, in our enjoyment of a piece of pottery." [15] Clark's recognition of this motive on the part of both artist and audience was intended to cut across the centuries; certainly it applies to Dater's photographs of nudes. Response to her portrait of *Nehemiah*, for example, may be compared to Clark's report on the public's reaction to Manet's *Olympia*: ". . . the true reason for their indignation was that for almost the first time since the Renaissance a painting of the nude represented a real woman in probable surroundings." [16] That the woman was a prostitute is relevant to this comparison only in that her body was her profession. Nehemiah, a black male with an extraordinarily supple body, is a professional model and dancer whose body is his profession in a different way. Both confront the viewer with a direct, if not arrogant, gaze that welcomes the expected voyeurism. For Dater, it was not only a chance to do something different, as it must have been for Manet, but an attempt to confront a social taboo. But as the arts continue to evolve, nudes, whether idealized or real, no longer have the social impact they once did. What the falsity of salon photography did for nude studies at the beginning of this century, "R"-rated films have done for contemporary attempts to take the nude as a subject of aesthetic concern. The "conquest of shame" referred to by Clark in his discussion of artists' confrontation of social and aesthetic mores has become today a conquest of contemptible familiarity.

Since 1980, Dater has explored the realm of self-portraiture, successfully incorporating aspects of both her earlier portraits of women and her nude studies. These earlier photographs fulfill the classic definition of empathy, which is to project one's own personality into the personality of another in order to understand her better. Dater's self-portraits divide into three areas of exploration: images of herself in nature, images of herself costumed as female stereotypes, and a live performance acted out with Sam Samore, companion and fellow artist.

The first two categories of self-portraits were begun in New Mexico, where Dater and Samore lived while he finished a master's degree in fine arts. The third was their first joint project performed in San Francisco in 1983 on their return from the Southwest.

During the two years in New Mexico, Dater initially experienced a deep sense of isolation and loneliness. She had lived in a cosmopolitan city for too many years, waking each morning to some new Californianism, not to be depressed by the natural slowing of time, cause, and effect characteristic of New Mexico. But she came to love the desert and for the first time in her career took the time (forced though it might have been) to analyze her work and herself. When contemplating the experience in retrospect, Dater again found Lucy Lippard's writing inspiring and referred to it in her lectures: "A volcanic layer of long-suppressed imagery has been surfacing in women's art about prehistory and nature, much of it anxious, angry, sexual, and painful—in the senses both of dealing with internalized pain and of being excruciatingly unfamiliar. The goal, however, is rarely narcissism or masochism (as some would have it), but transformation. The imagery is intended to dispel taboos and is part of an exorcizing and healing process."[17]

It is no wonder that Dater admires Lippard's writing in *Overlay*. It is a perfect description of what Dater discovered about herself and undertook in her first self-portrait series of black-and-white prints. In contrasting her work in this series to that of another woman artist who photographed female nudes in nature, Annie Brigman, Dater has said, "I see hers as visions of the perfect, idealized, romantic view of woman. I don't think mine are perfect or idealized—heroic, perhaps—but sometimes lumpy and rough, sometimes sensual."[18] Through this series of photographs of herself, Dater empathized with nature in a free and uninhibited way. She had exorcised the final taboo, that of stripping herself bare, both figuratively and literally, for all to see and judge. She had come to terms with the immutable fact that she, like everyone and nature, is imperfect, mortal; as Fred Sommer has said, "It is when you have become the helpless observer of your own research that you have reached learning."[19]

From this straightforward self-portrait series Dater moved to a group of color photographs in which she dressed and posed herself as stereotypes of certain kinds of women—*Ms. Clingfree* (page 89), *Queen of the Night* (page 95), *The Magician* (page 91), and others. She created different draped backdrops and used various props to signify the meaning of each setting. She was in fact now performing for the camera as she had fantasized about doing as a child in her father's theater. She was also preparing for a trial run at a public performance piece with Sam Samore, titled *En Abyme* ("slice of life").

Concerning these color self-portraits that are intended to be less autobiographical than one might think, Dater has said, " . . . even though they have humour, there is also an intense seriousness about them. Basically they represent the modern woman's dilemma. They are characters out of my own consciousness and the

collective unconscious, and each one of the women portrayed represents a certain type of woman's concern, either positive or negative. They represent things that women might think about, and I've certainly thought about when I've been home [alone] myself. And I was home a lot during the time when I was doing them—like the idea of the housewife [*Eating* (page 92)]. She doesn't have to work and she is left at home to watch soap operas all day and she is sitting there eating bonbons, and she is bored to death, so she fantasizes and eats, and there is something kind of amusing and pathetic about it at the same time. You just get fat; then you try to do all the popular things to get yourself back in shape like lifting weights . . ., and there she is looking like a fat pig, but she is trying!

"With the woman in the leopard suit [*Leopard Woman* (page 90)]—I wanted to show a tough, sexy kind of strange, Hollywood-type whom you had best not cross . . . basically a fantasy. Some feminist women have not wanted to see a woman looking like that. To me, this series is more feminist than anything."[20]

This self-portrait sequence was a finite series created in 1982 that helped Dater fully integrate herself into her photography in a more direct way. But it was more than an "exorcising and healing process" described by Lippard. It also represented her break with the "straight" aesthetic and "ideal form" that had been both her heritage and her trap since she began photographing in 1963. Critic Donna-Lee Phillips summed up the meaning of this series with great perceptiveness: "They are her earlier portraits turned inside out so that all the seams show. Her Urban Women of the 1970s were essentially expressions of fantasy and theater—and of the unquestioned assumption that such portraiture constituted an appropriate use of photography. Here she has turned the fictionalizing photographic gaze back on itself, away from the exploitable 'other' and onto the vulnerable 'one'.[21]

Dater's first involvement with performance and installation art was indirect and spontaneous. In 1976 she and Jack Welpott were invited to teach a workshop on nude photography at the Rencontres Internationales de la Photographie in Arles, France. Each year for more than a decade this organization has presented international workshops on photography taught by leading artists from around the world.

Many of the classes for this particular "rencontres" were held in a large stone building which had several empty rooms. One early morning when Dater was not teaching, she wandered through the building and came to one of the abandoned rooms, which had very high ceilings, small windows, and a large fireplace. The wall surrounding the fireplace had steel rods projecting out of it into the room at various points. In the faint light she saw several nude men and women models frolicking about the room, climbing the stone wall while a fire burned in the fireplace. Without interfering, but seeing the event as a special performance, she began to photograph. The resulting images she organized into an installation wall piece containing seven sixteen-by-twenty-inch photographs titled *Arles Suite* (pages 57 to 59).

This event, brought to personal completion by Dater through her photographs of it, contains the essential components of a performance work of art with the exception of a planned audience. Dater's final solution to showing the piece involved hanging

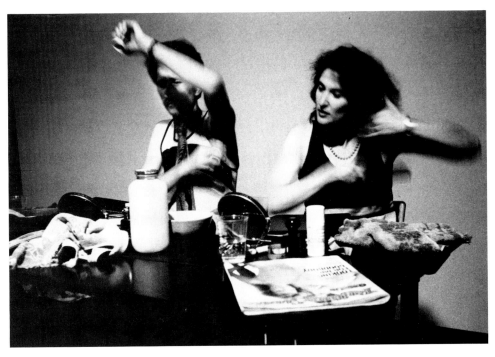

Judy Dater and Sam Samore in the production of En Abyme

the seven photographs together in a specific arrangement that provides a visual sense of the original performance as it took place.

The *Arles Suite* may not have been a planned performance in the way we think of such artistic activities today, but it did have a significant impact on the way Dater began to think about her photography. It was the first step toward a new expression in her work and sensitized her to possibilities that were later reflected in her self-portraits representing archetypical women and in the performance event produced with Sam Samore.

This performance, *En Abyme* ("slice of life"), took place in San Francisco at a performance space called La Mamelle, Inc., on June 3, 1983. The event was auto-biographical for both Dater and Samore, but it also parodied "real" life as seen through magazine advertising and the body-beautiful values promoted and con-sumed by the young, urban, professional generation. There were three sequences to the performance, each introduced by diary-like readings, first by Dater and then by Samore. The subsequent dialogue between them was drawn from the style of language and sometimes direct use of text from magazines such as *Gourmet*, *Vogue*, and *Esquire*. The diary pieces were read "live" and the dialogue was taped with new-wave background music. Movie-screen-size slides were projected upstage, repeating and reinforcing the glamorized materialism of life portrayed by the advertising world.

Dater's *Somewhere Over the Rainbow Blues* (pages 96, 97, and 99), another installation of multiple photographs, was made in 1985. It is related to both *En Abyme* and the *Arles Suite* in that it is autobiographical and experimental in technique. It consists of sixteen twenty-by-twenty-four color prints made from video images and computer text. The installation is designed so that the photographs are hung in a specific arrangement that narrates and illustrates an experience in Dater's life. Photographs of an unidentified midwestern location alternate with photographs of text that Dater has written to tell a story. The text tells what it was like for her to live at a midwestern art school where she spent five weeks as a guest artist. It takes the viewer (reader) through her room, describing in detail the less than attractive physical qualities of its construction and furnishings. She comments on its lack of privacy and previous occupants. The title includes the word "Blues" so it is obvious that her romantic notion of the Midwest (*Somewhere Over the Rainbow*) has been tarnished by a living environment of bare essentials. But the text moves quickly to a warm positive association she finds when visiting a life-size, painted sculpture of Kuan-Yin (eleventh to twelfth century) in a nearby museum. The god of mercy and compassion, this sculpture became her spiritual mentor: "Her serene, sensuous face and self-contained presence had me spellbound. She was magnificent, elegant, awesome, yet warm and human. I felt she could and would speak to me, comfort me, sustain me while I remained here." This excerpt from the text suggests that, as in New Mexico, the difficulty of living and working in an environment so different from San Francisco moved Dater to explore new directions in her work. As she had done in the Southwest, Dater turned the emotional contrasts of her experience into a work of art that is an internal self-portrait.

The past twenty years have seen an enormous growth in the number of recognized photographers, but few have changed the way we look at the world through their art. Dater and a select group of her peers have by their vision added new dimensions of uniqueness to the photographic medium and, in doing so, have broadened our expectations of photography as an art form. No one expects photographs merely to define and to depict "reality"; the art world recognizes the much wider potential of photography. Betty Hahn, Bea Nettles, and Barbara Kasten expanded the vocabulary of the medium to include a wide variety of photographic processes. Their finished works, though not photographs, are new photographic objects still belonging under the rubric of photography. Emmet Gowin, George Tice, and Paul Caponigro extended their visions in the opposite direction and unveiled new subjects for the large-format negative. Jerry Uelsmann and Robert Heinecken developed technical and philosophical approaches to subject matter that questioned the historical notions of "appropriate" subjects for photography. Lee Friedlander and Gary Winogrand stripped the medium of its last pictorial vestiges, emphasizing composition regardless of subject matter.

Dater's contribution to and impact on photography has been equally unique. From the fabric of her subjects' individualism she has forged a new set of aesthetic tenets for photographing people. Departing from portraiture as a search for the less

familiar aspects of humanity (as in the work of Diane Arbus), Dater has given the most familiar of subjects greater universality. The history of portraiture must now include the camera's potential to reveal more than it captures, to confront its own abstraction of reality, and to merge the spirit of artist and subject in a way that is not unlike the mental joining that takes place between any artist and the material at hand. This has been Dater's constant message to the photography world. Her recent investigation of the blending of media, in her performance and installation pieces, suggests that Dater, like her fellow artists of the first rank, has only begun to test the application of photographic ideas with a broader art-world audience.

The next twenty years may very well see the end to the object-oriented photographs that we know today, but it is likely that Dater will be working in the forefront of the medium, whatever its form.

<div align="right">James L. Enyeart</div>

NOTES

1. "California Photographers: A Perspective," *Nob Hill Gazette*, Joan Murray (February 1984), p. 17.
2. Tucker, *The Woman's Eye* (New York: Alfred A. Knopf, 1973), p. 142.
3. "Seeing People Through the Artistry of Judy Dater," *The Fresno Bee*, David Hale (October 14, 1981) p. H1.
4. Letter to the author, September 11, 1984.
5. *Photo Bulletin* (G. Ray Hawkins Gallery, December 1979), Vol. II, No. 8.
6. Ibid.
7. "Photographer Seeks Artistic Risk," *The Billings Gazette*, Christine Meyers (April 24, 1983), n.p.
8. *The Fresno Bee*, David Hale, p. H2.
9. "The Many Faces of Judy Dater," *Darkroom*, Richard Senti (November 1983), Vol. 5, No. 7, p. 28.
10. Letter to the author, September 16, 1979.
11. *The Fresno Bee*, David Hale, p. H2.
12. Lippard, *Overlay: Contemporary Art and the Art of Prehistory* (New York, Pantheon Books, 1983), p. 46.
13. Clark, *The Nude* (Garden City, New York, Doubleday Anchor Books, 1956), p. 27.
14. Ibid., p. 27.
15. Ibid., p. 29.
16. Ibid., p. 224.
17. *Overlay*, Lippard, p. 47.
18. Letter to the author, September 15, 1984.
19. *Frederick Sommer*, exhibition catalogue (Philadelphia College of Art, November 1–November 30, 1968), Gerald Nordland, p. 9.
20. *Darkroom*, Richard Senti, p. 27.
21. "Personas of Women," *Artweek*, Donna-Lee Phillips (March 31, 1984), p. 15.

EARLY WORK

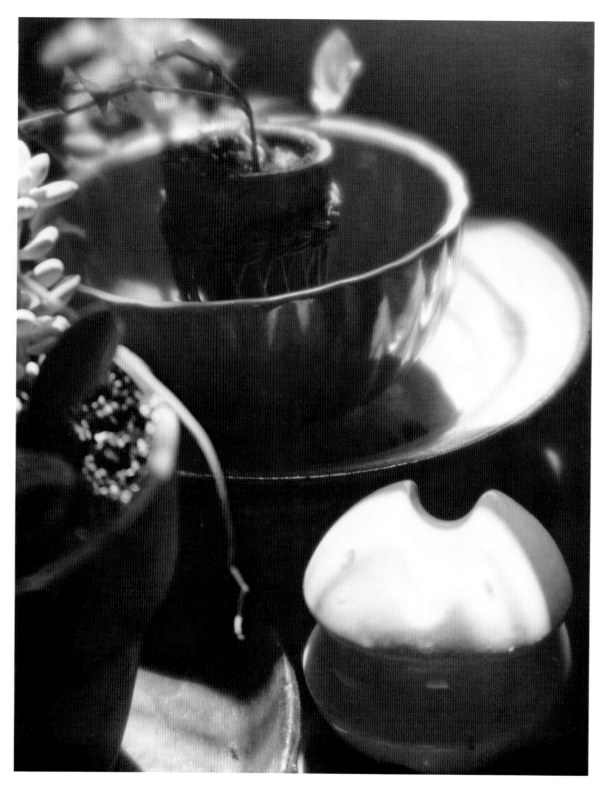

IMOGEN'S THINGS, 1971 / PLATE 13

2

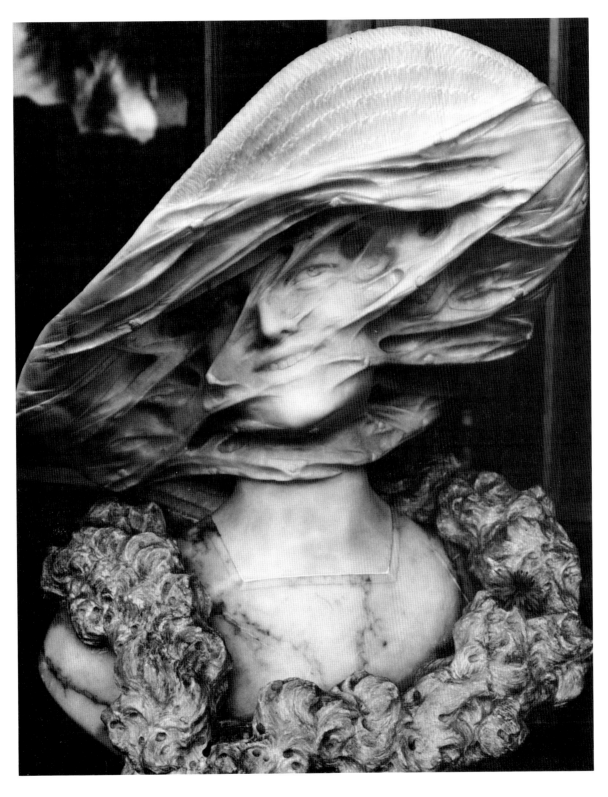

ALABASTER BUST, 1964 / PLATE 1

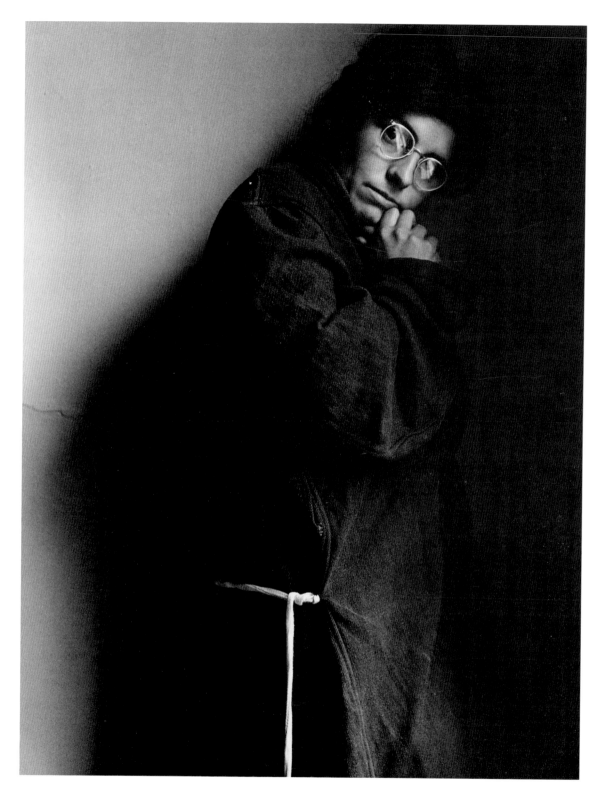

ANNA, 1964 / PLATE 2

4

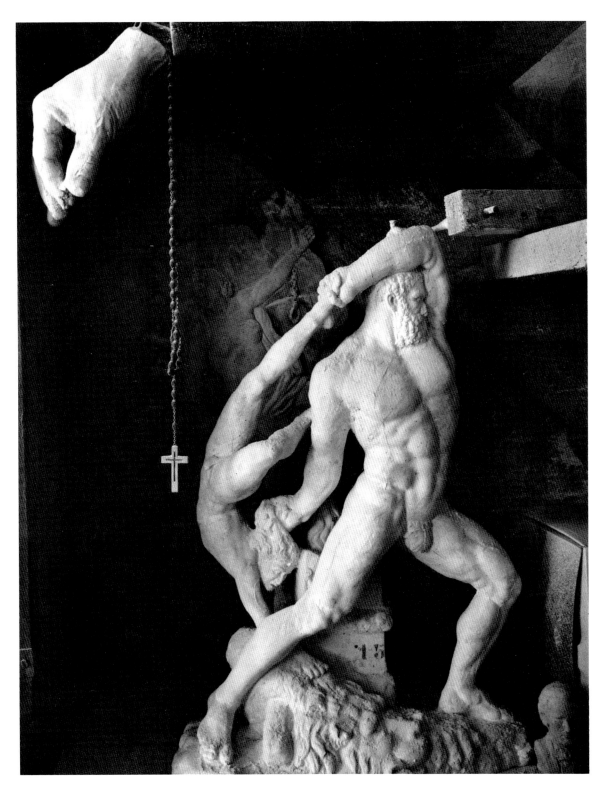

STATUE, CROSS, AND HAND, ITALY, 1976 / PLATE 38

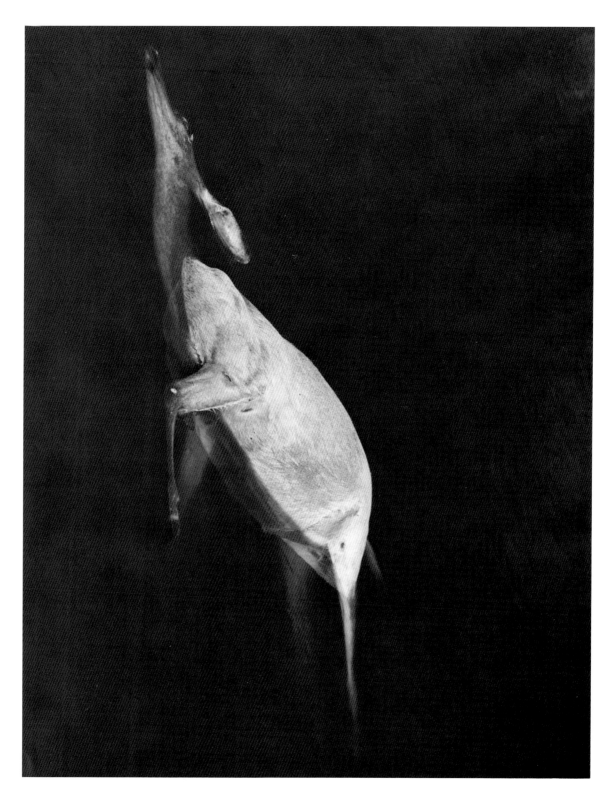

DEAD DEER, 1966 / PLATE 5

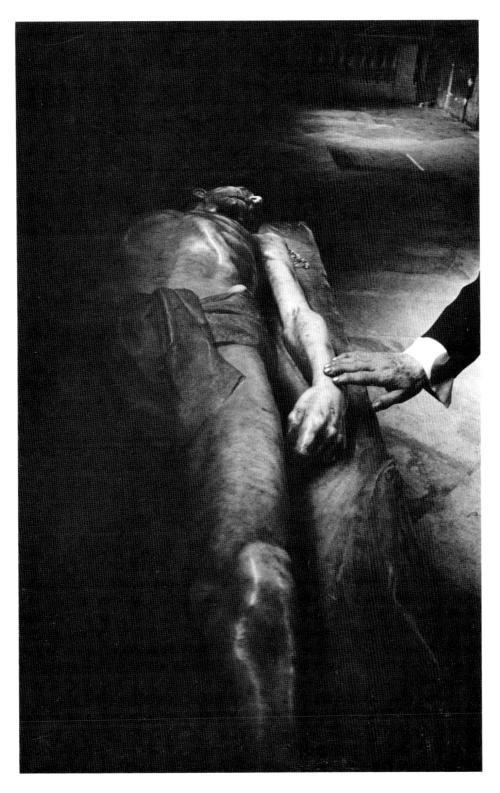

AT NAPOLEON'S TOMB, PARIS, 1967 / PLATE 7

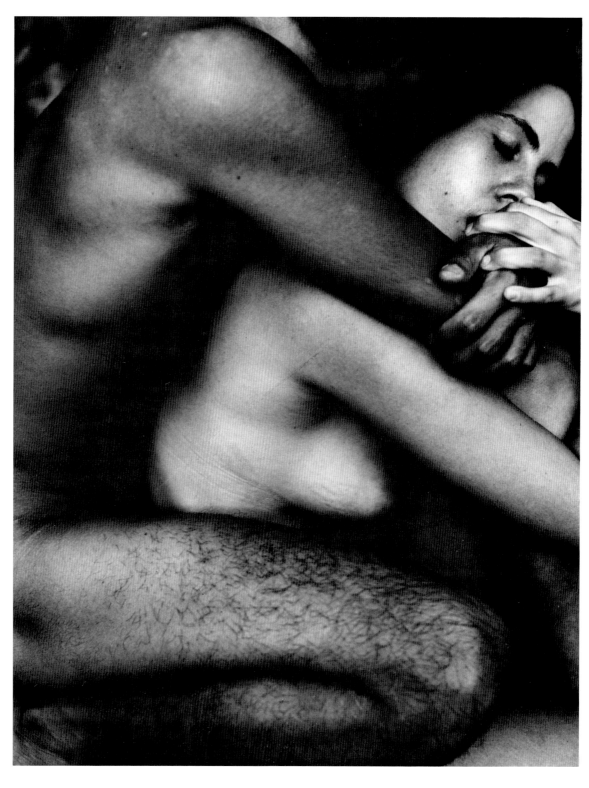

LOVERS, 1964 / PLATE 3

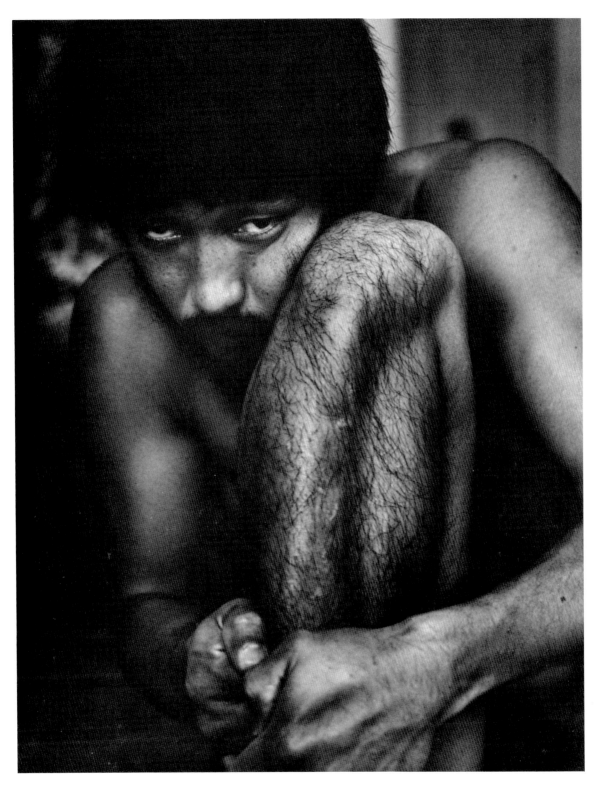

SIECHI, 1964 / PLATE 4

MEN AND WOMEN

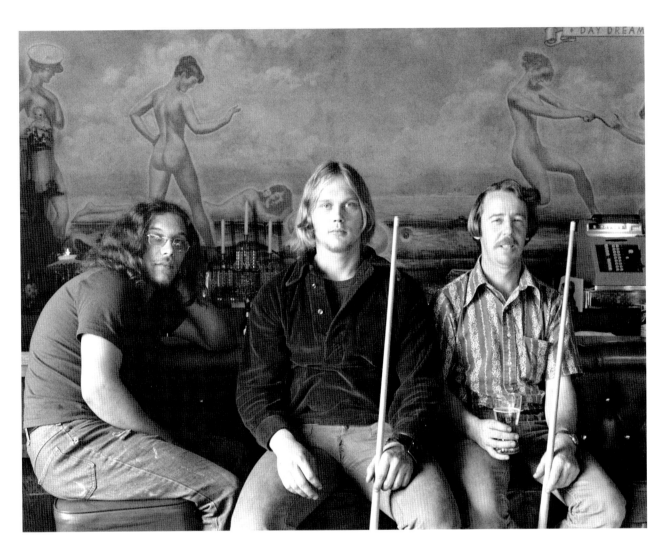

DAYDREAMS, 1973 / PLATE 24

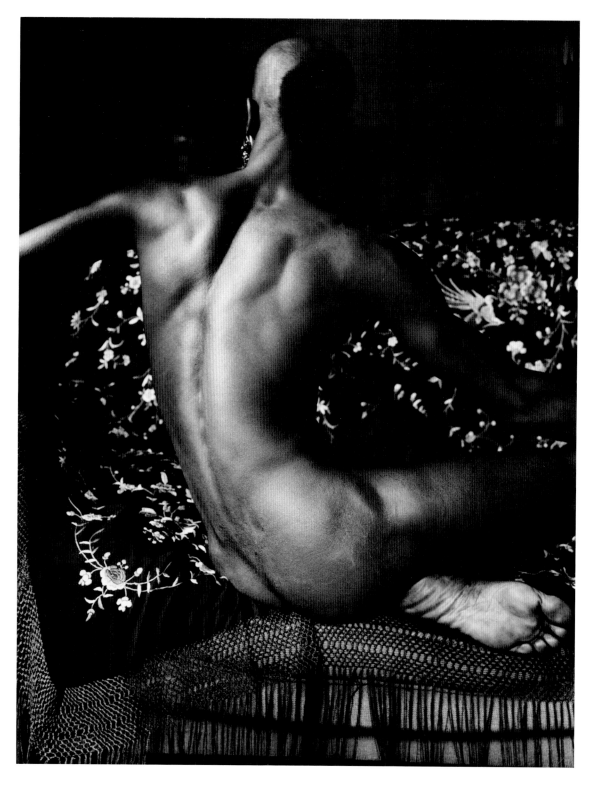

NEHEMIAH, 1975 / PLATE 30

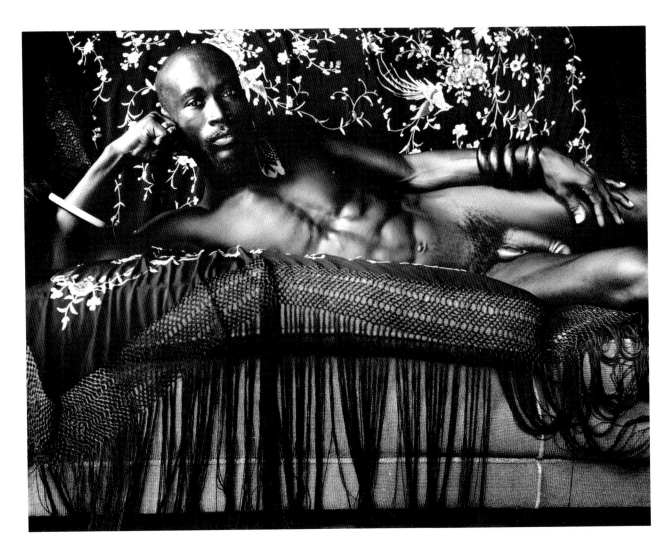

NEHEMIAH, 1975 / PLATE 31

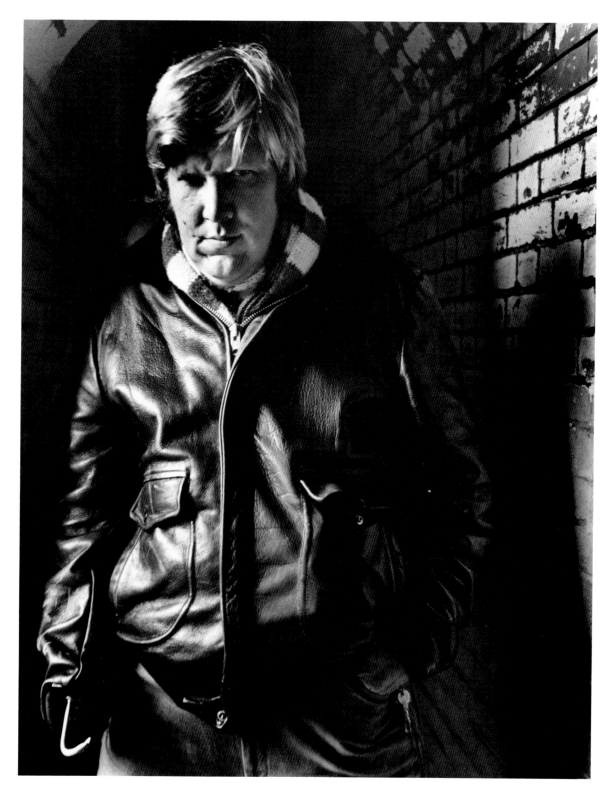

JIM HENDRICKSON, 1978 / PLATE 43

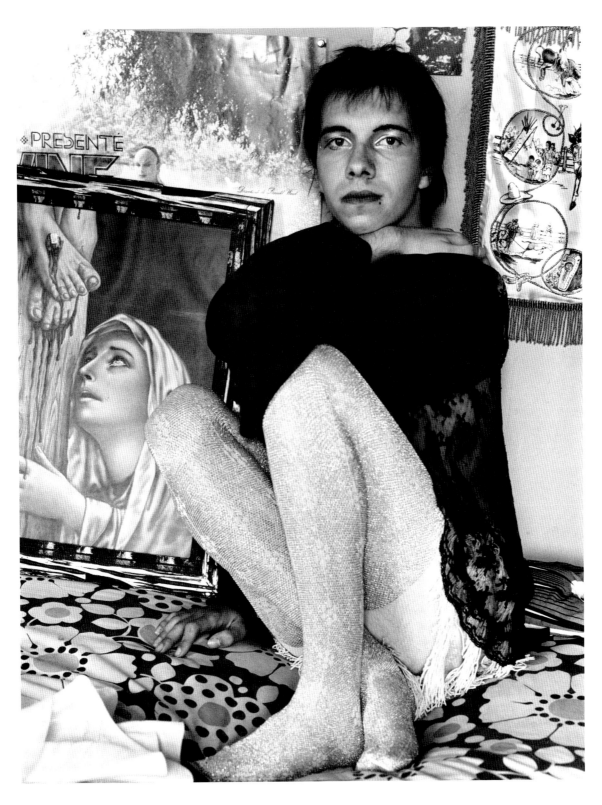

AARMOUR STARR, 1972 / PLATE 19

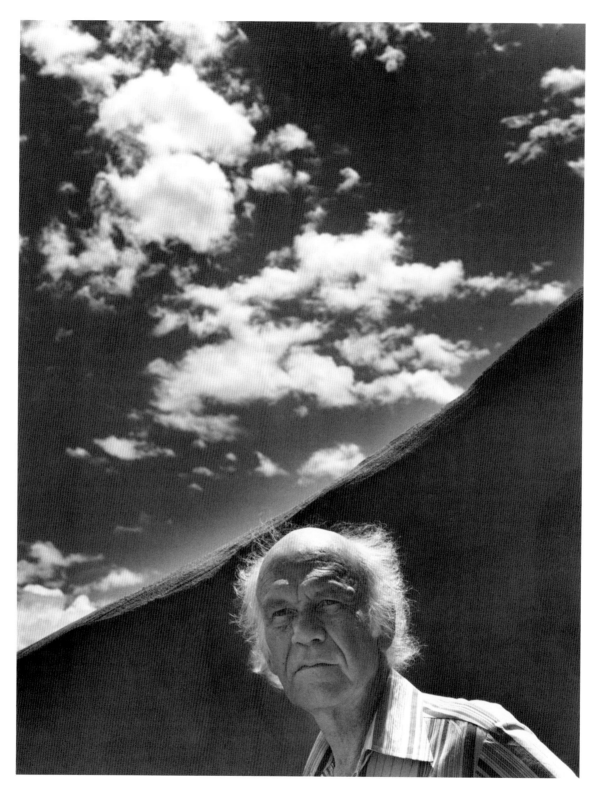

BEAUMONT NEWHALL, 1977 / PLATE 41

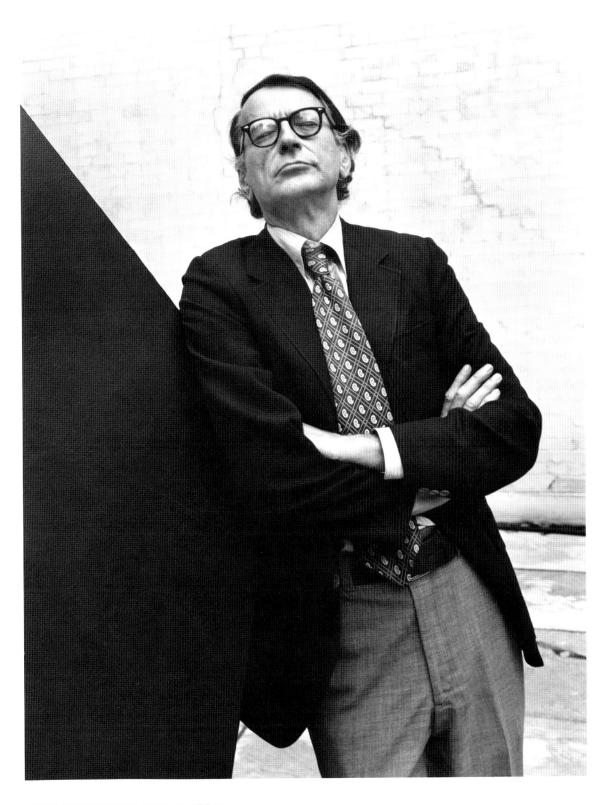

JOHN SZARKOWSKI, 1978 / PLATE 46

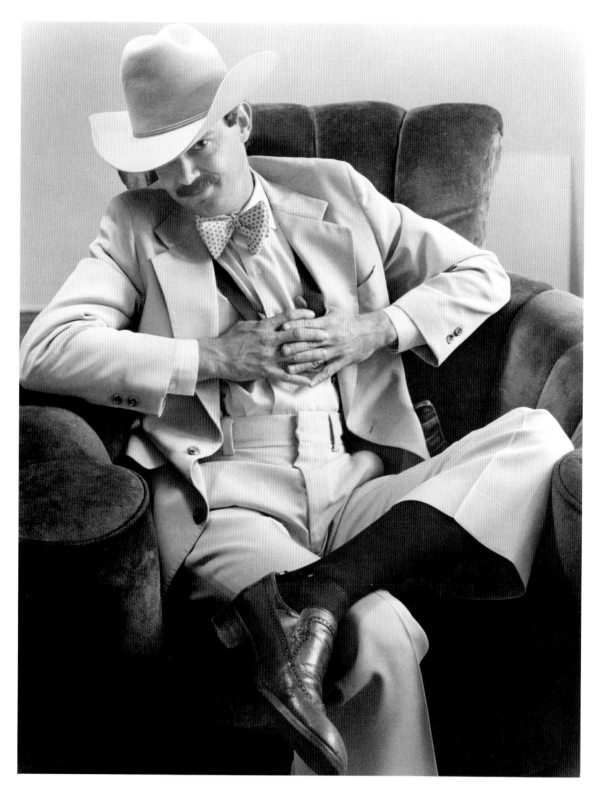

HAROLD JONES, 1975 / PLATE 29

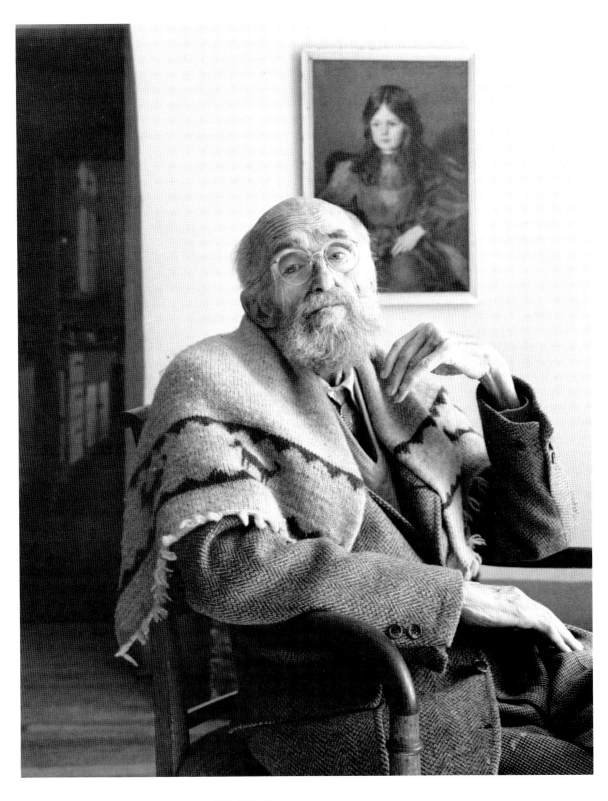

JOHN GAW MEEM, SANTA FE, 1980 / PLATE 61

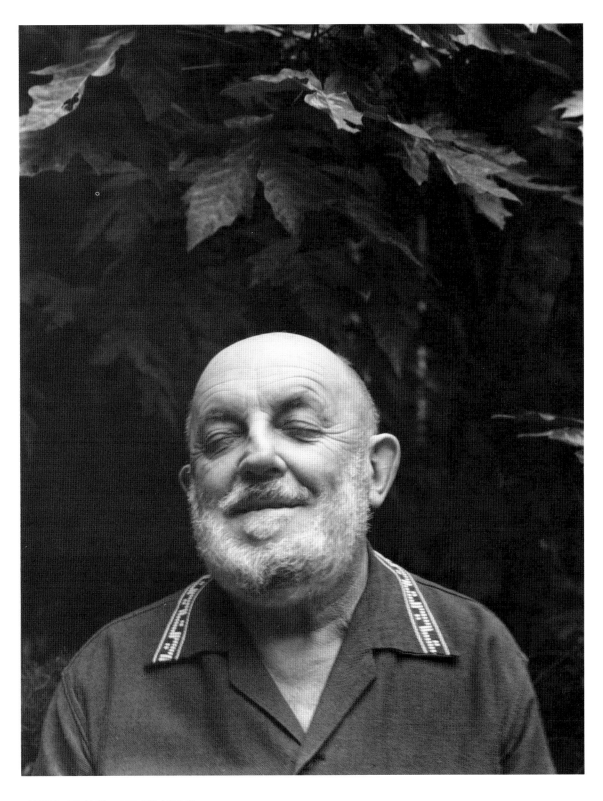

ANSEL ADAMS, 1977 / PLATE 39

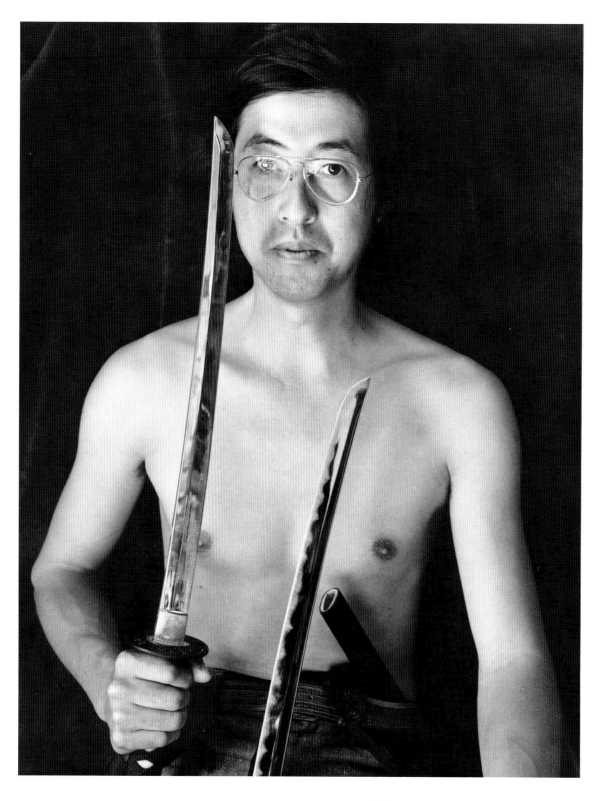

PATRICK NAGATANI, 1978 / PLATE 45

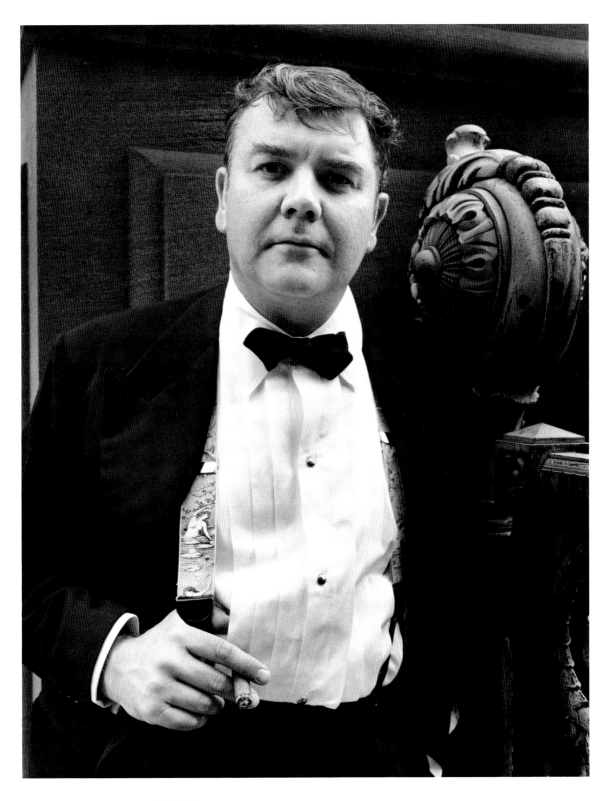

PETER BUNNELL, 1977 / PLATE 40

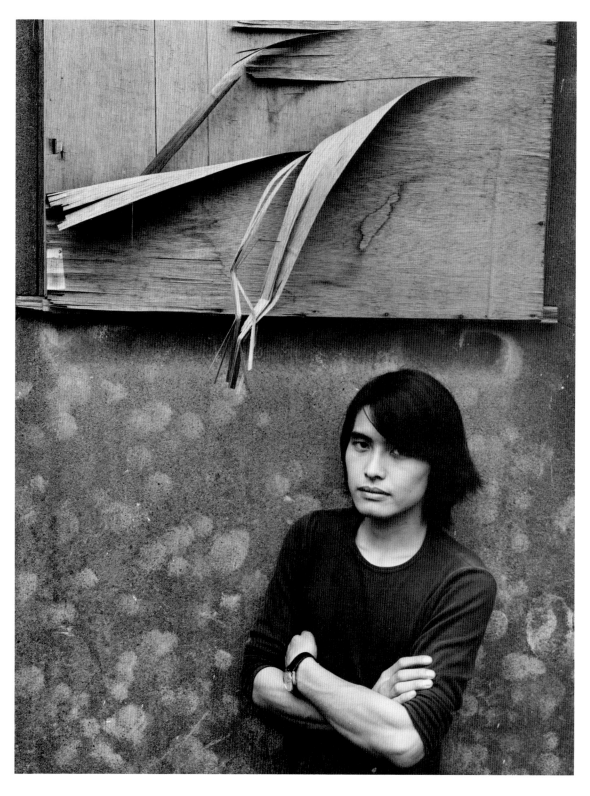

YOUNG MAN, TOKYO, 1978 / PLATE 37

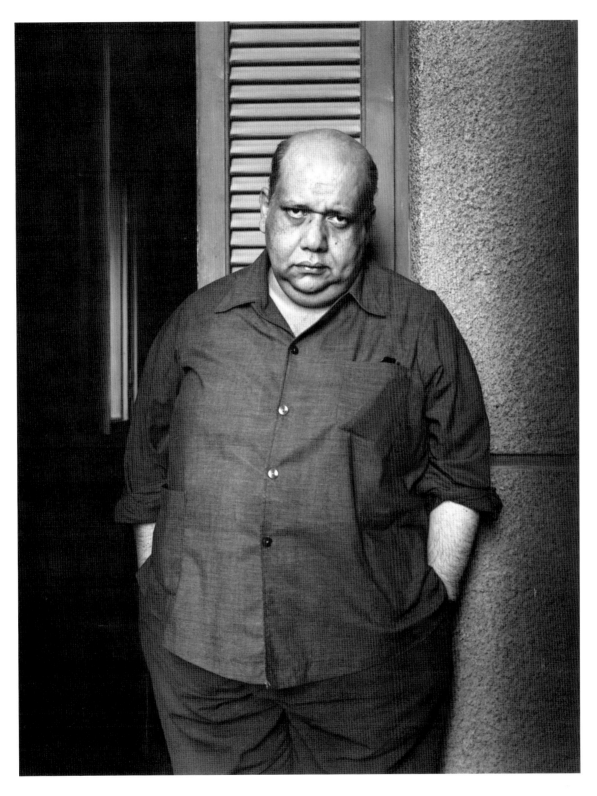

SALAH JAHINE, CAIRO, 1980 / PLATE 60

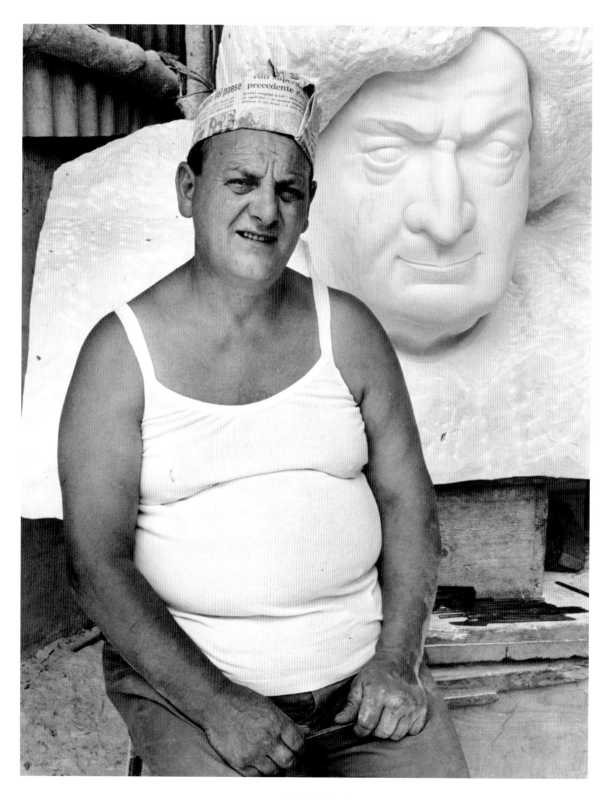

STONECUTTER, PIETRA SANTA, ITALY, 1976 / PLATE 36

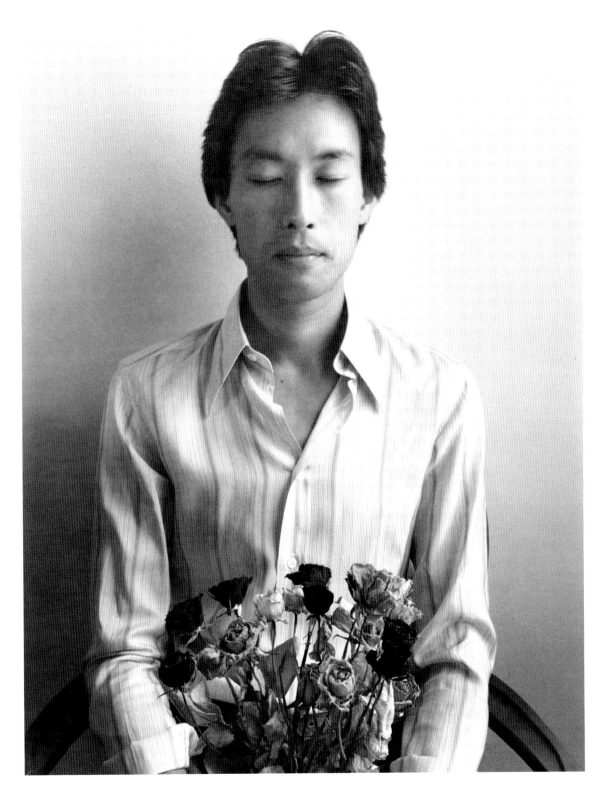

HIDE, 1978 / PLATE 44

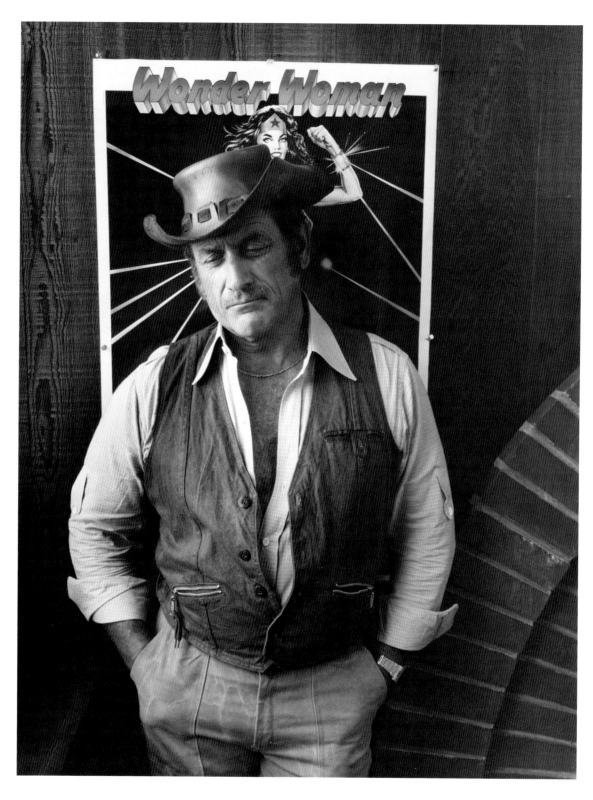

BERNIE, 1978 / PLATE 42

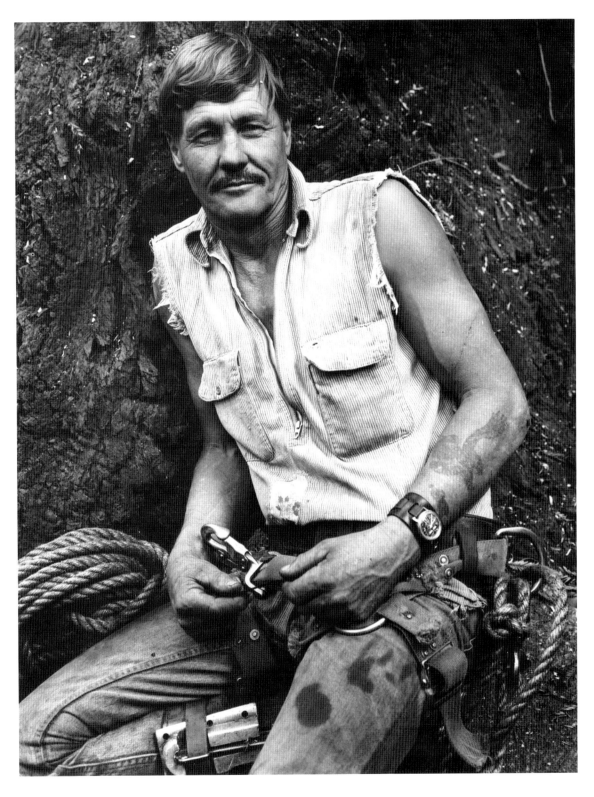

SANDY, 1975 / PLATE 32

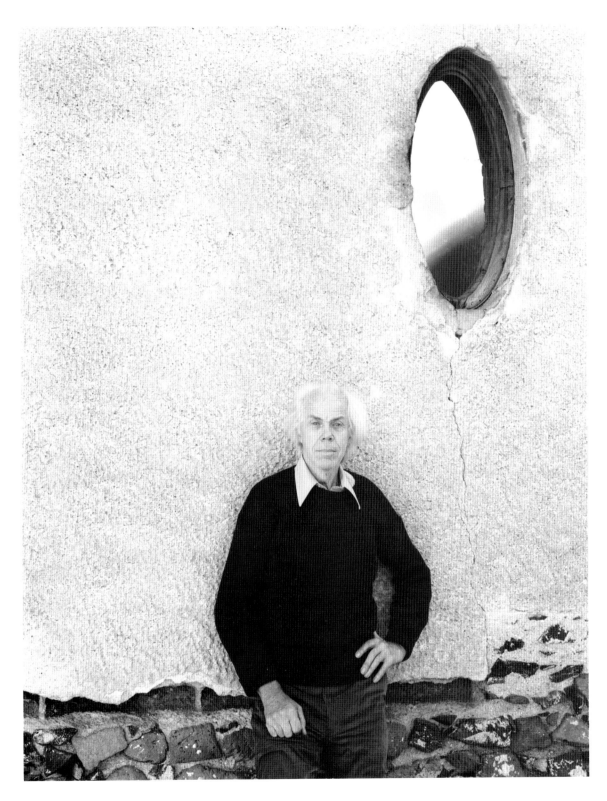

MINOR WHITE, 1975 / PLATE 33

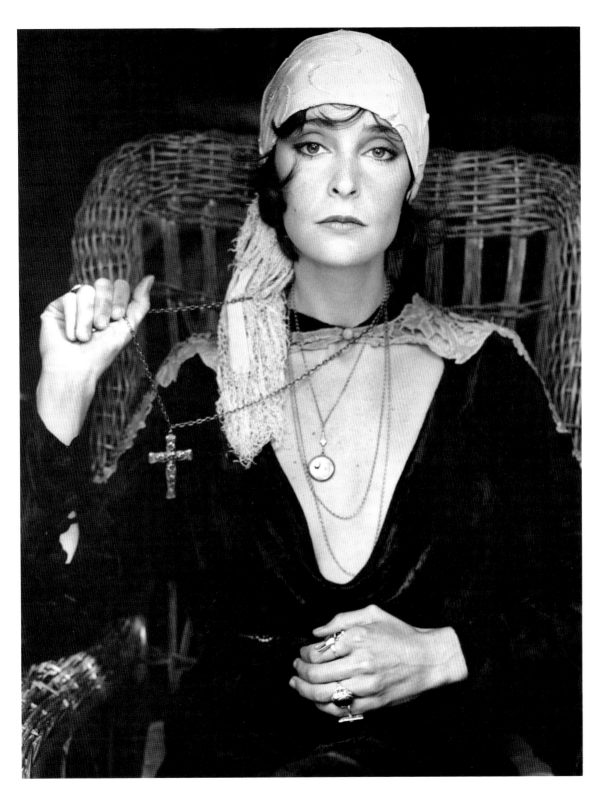

KATHLEEN KELLY, 1972 / PLATE 22

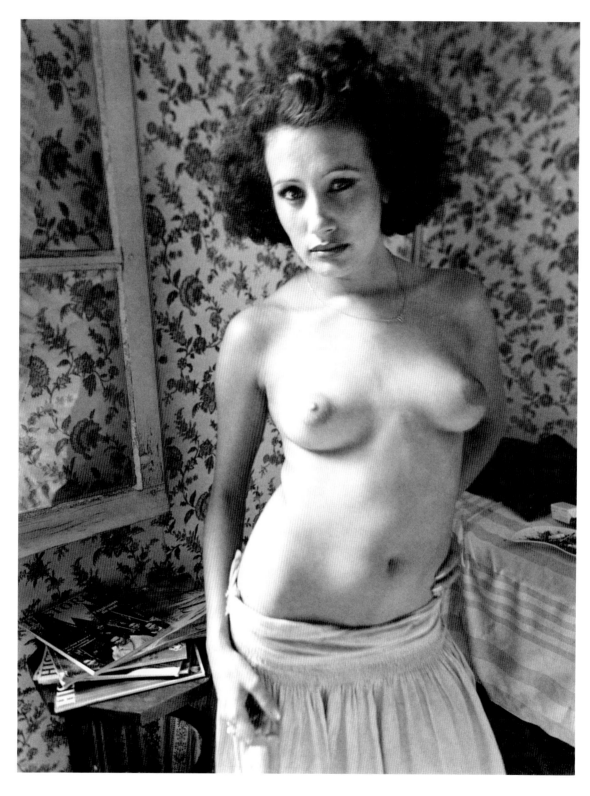

SABINE, 1973 / PLATE 26

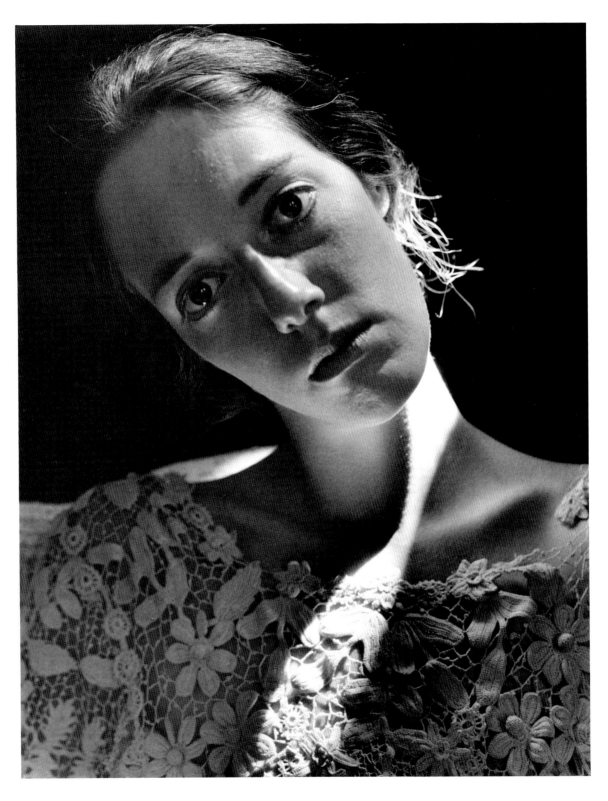

GWEN, 1972 / PLATE 20

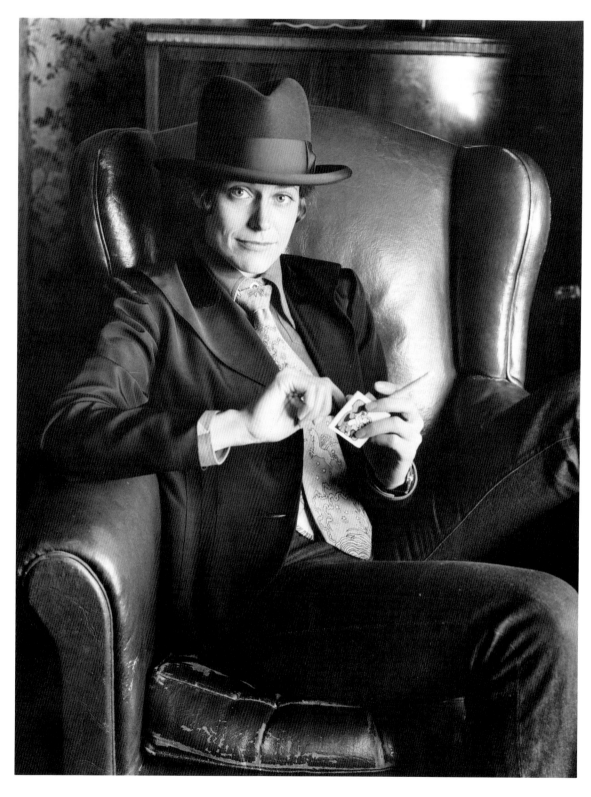

LAURA MAE, 1973 / PLATE 25

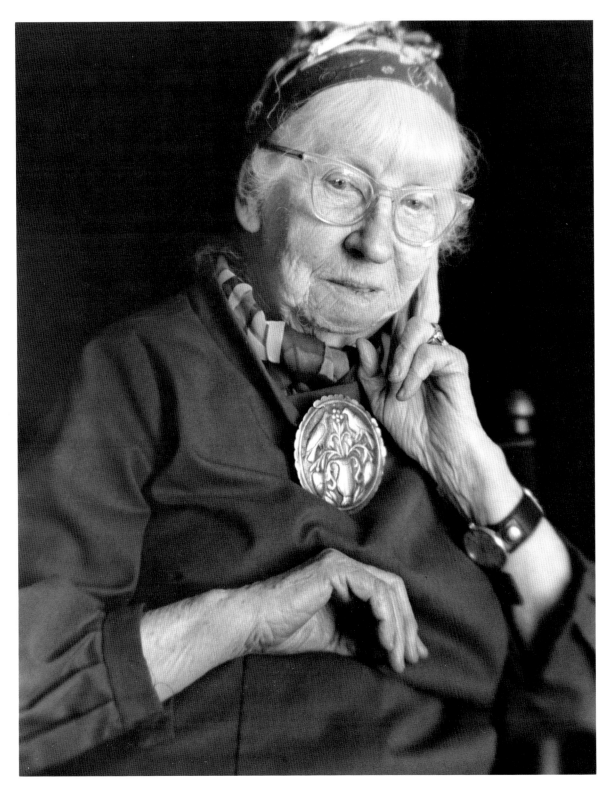

IMOGEN CUNNINGHAM, 1971 / PLATE 14

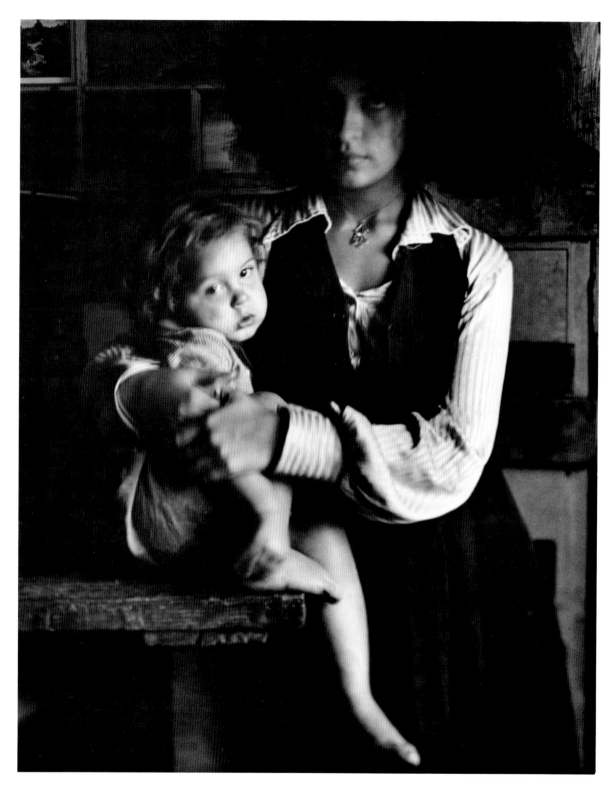

MARIA AND LEGEND, 1971 / PLATE 16

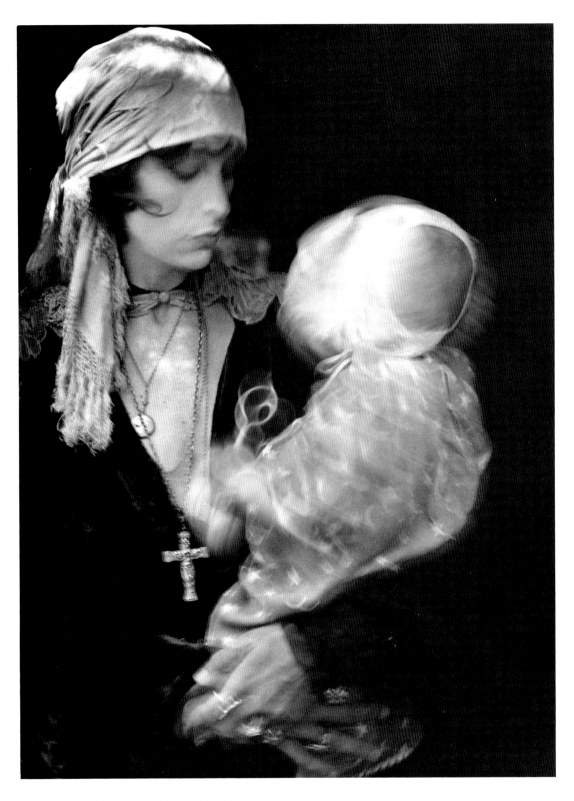

KATHLEEN AND CHINA, 1972 / PLATE 21

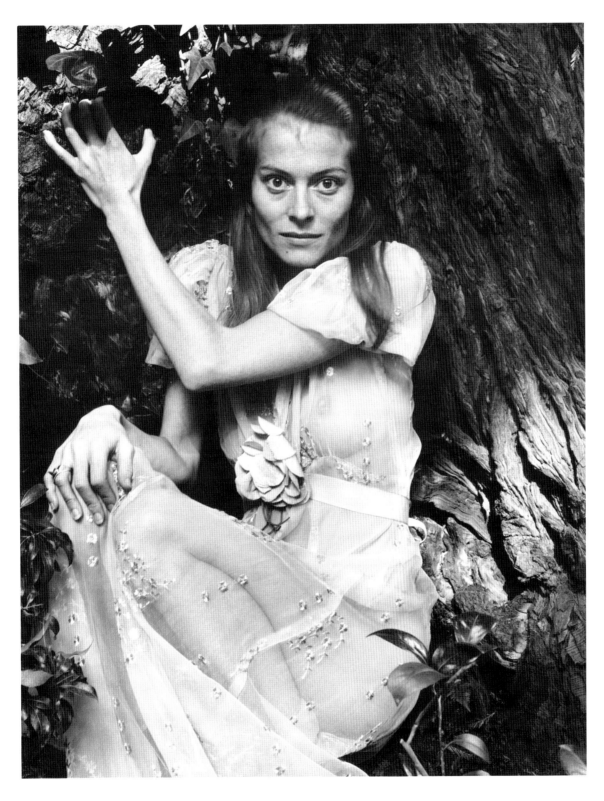

TWINKA THIEBAUD, ACTOR, MODEL, WRITER, 1970 / PLATE 11

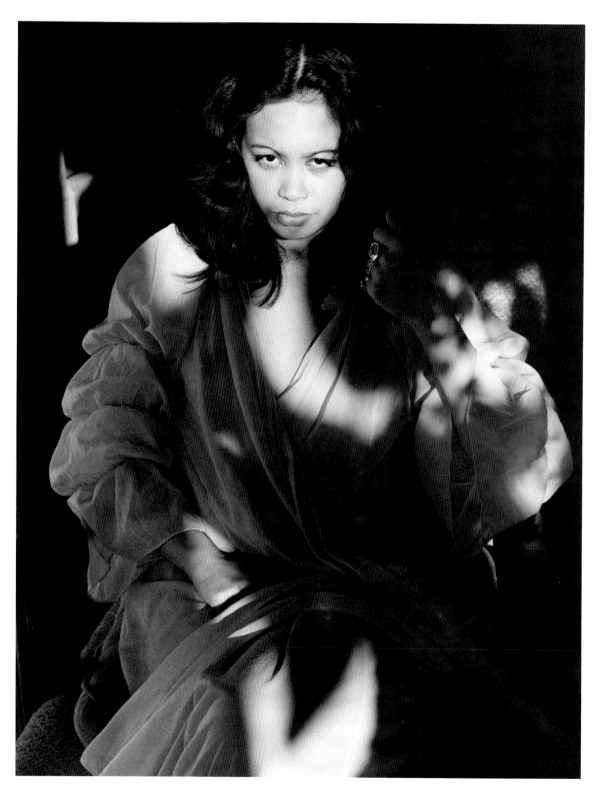

MARIA THERESA, 1974 / PLATE 28

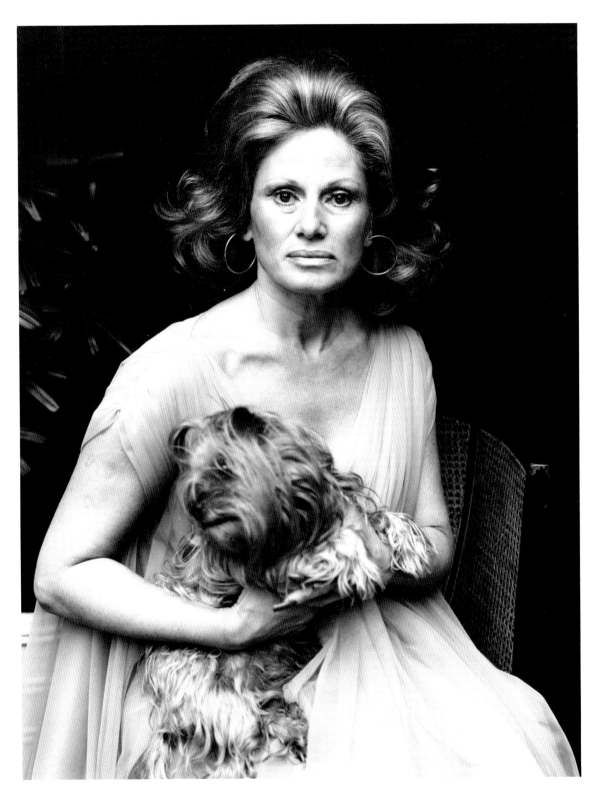

WOMAN AND DOG, BEVERLY HILLS, 1972 / PLATE 23

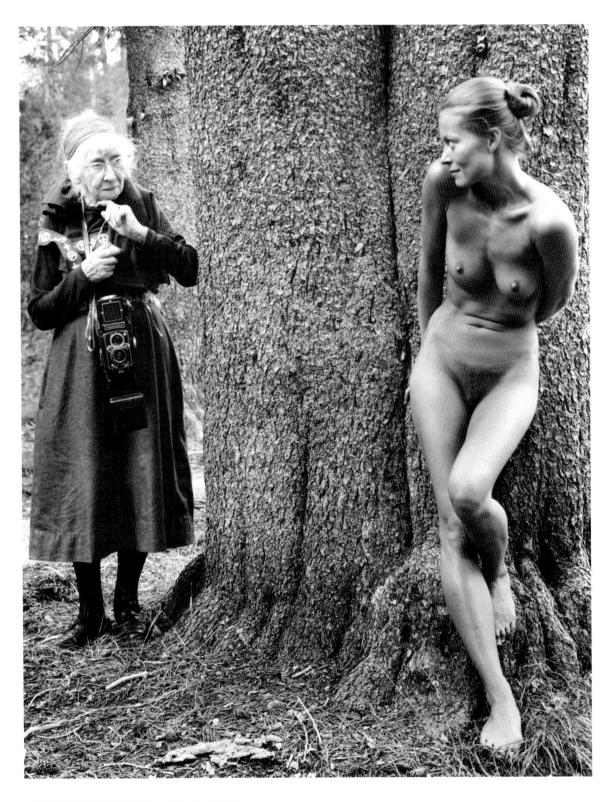

IMOGEN AND TWINKA, 1974 / PLATE 27

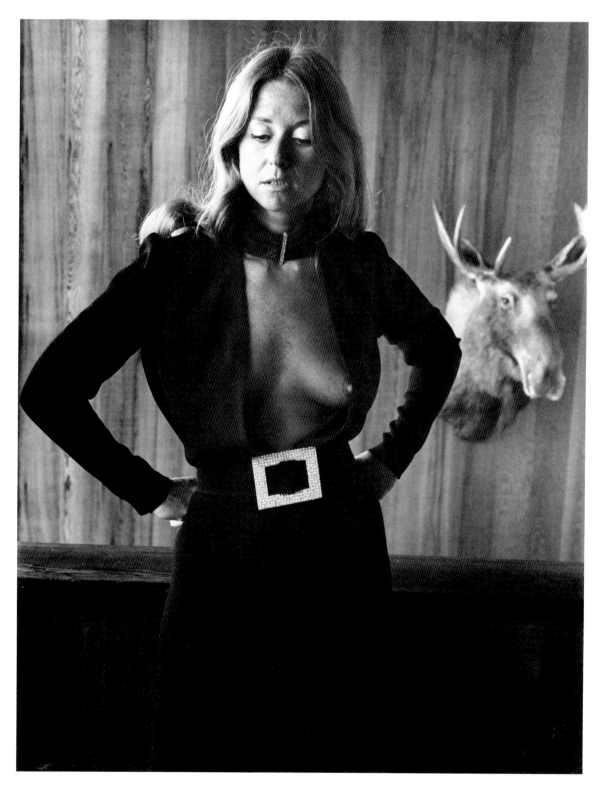

LIBBY, 1971 / PLATE 15

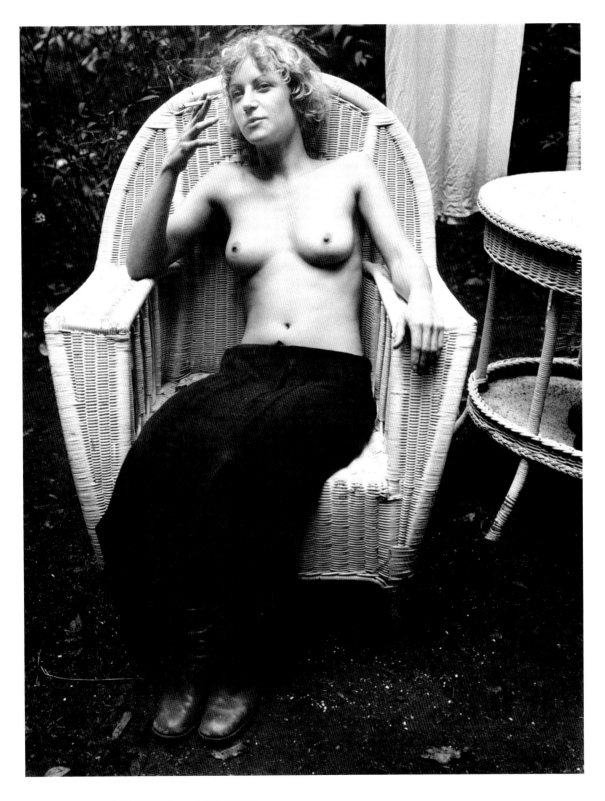

MAGGIE WELLS, PAINTER, 1970 / PLATE 12

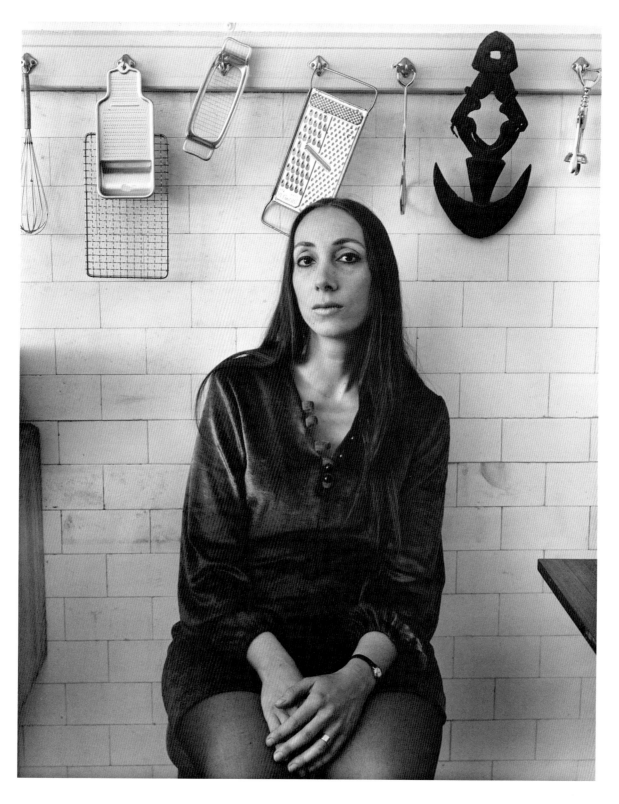

JOYCE GOLDSTEIN, 1969 / PLATE 9

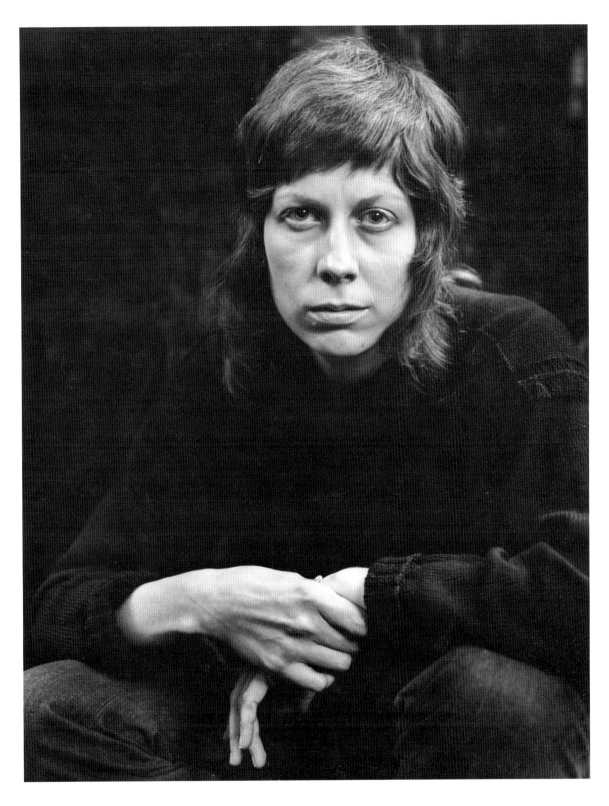

JANET STAYTON, PAINTER, 1971 / PLATE 18

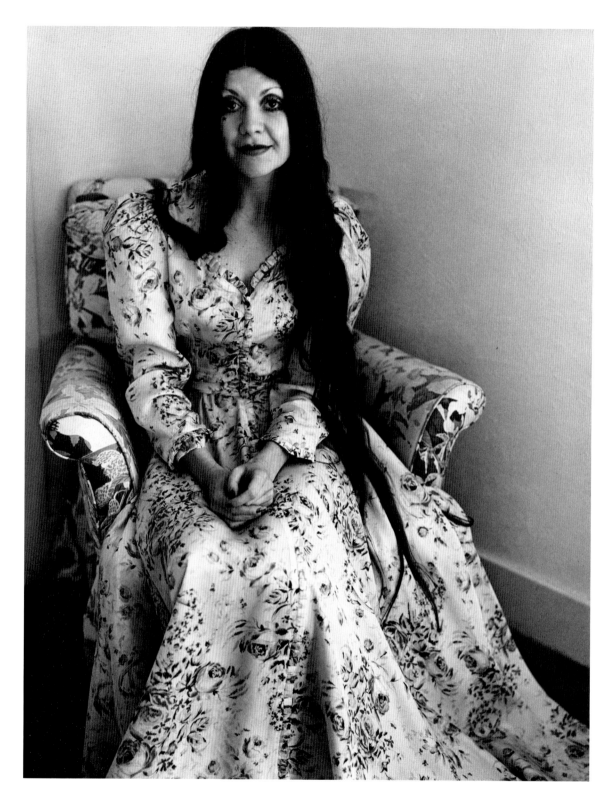

SUSAN REMY, 1971 / PLATE 17

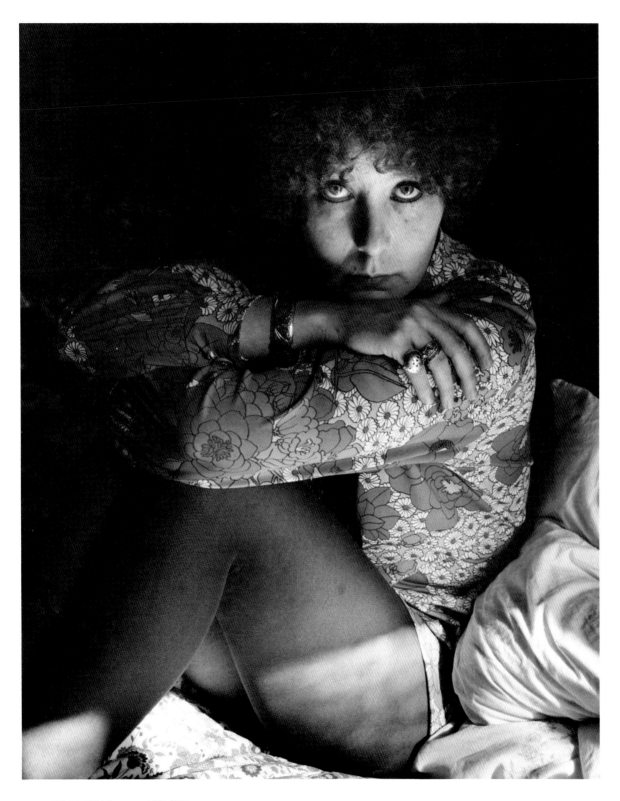

VALERIE DUVAL, 1969 / PLATE 8

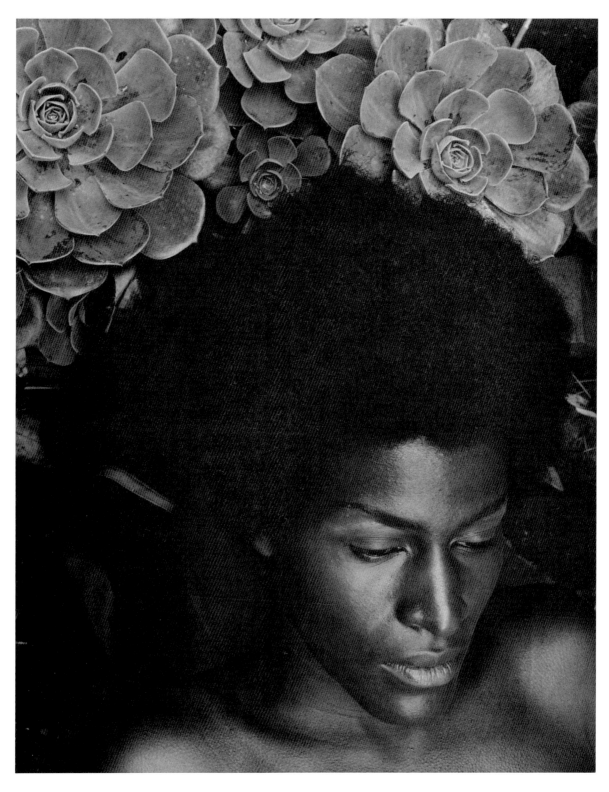

SHARON MOORE, 1970 / PLATE 10

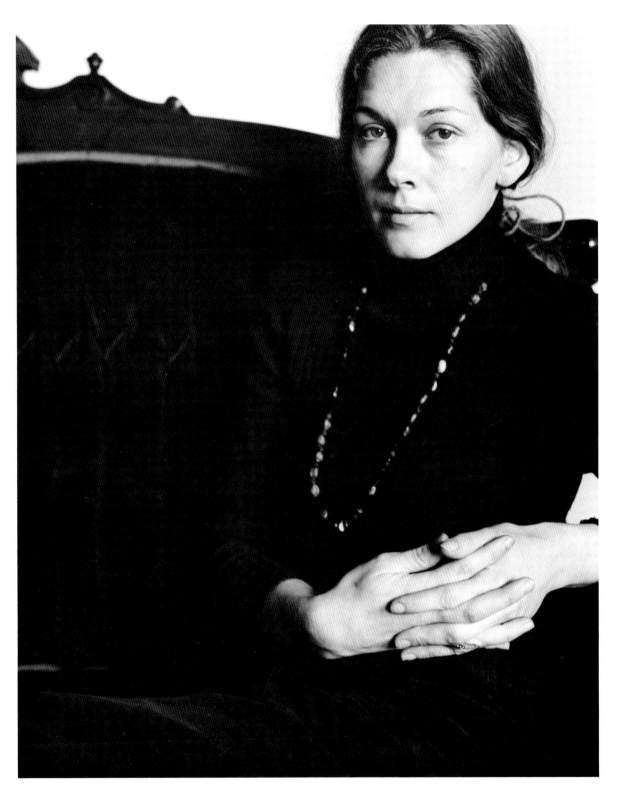

WOMAN FROM THE MARSHALL HOTEL, 1966 / PLATE 6

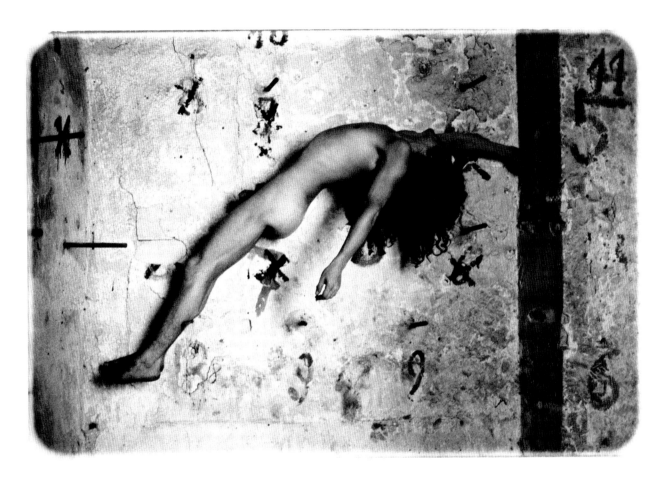

ARLES SUITE, NO. 2, 1976-78 / PLATE 34

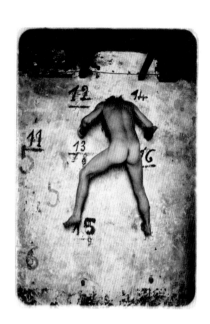
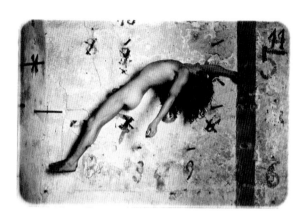
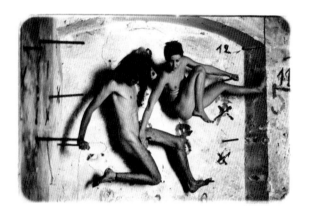

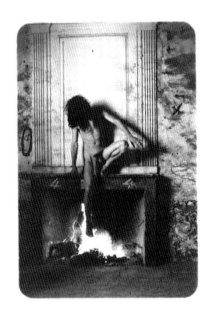
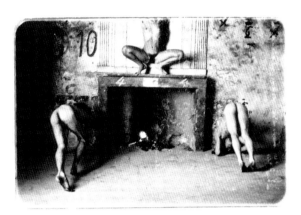
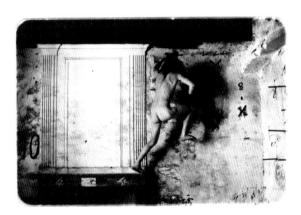
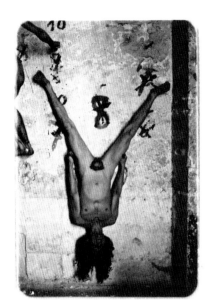

ARLES SUITE, NOS. 1-7, 1976-78 / PLATE 35

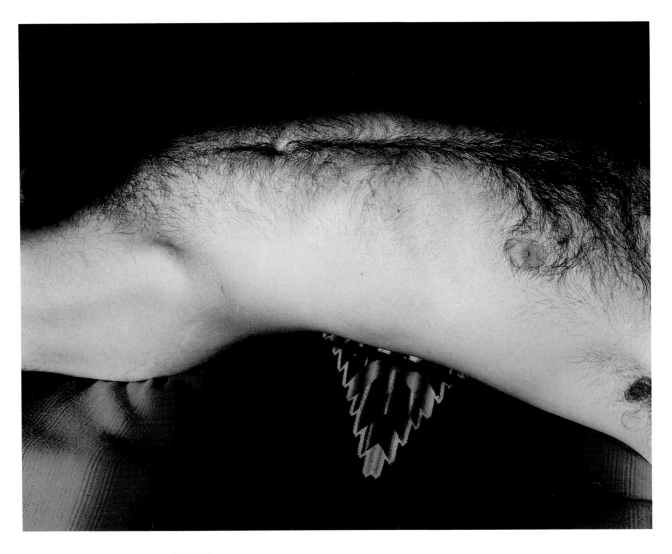

TORSO AND SERAPE, 1981 / PLATE 62

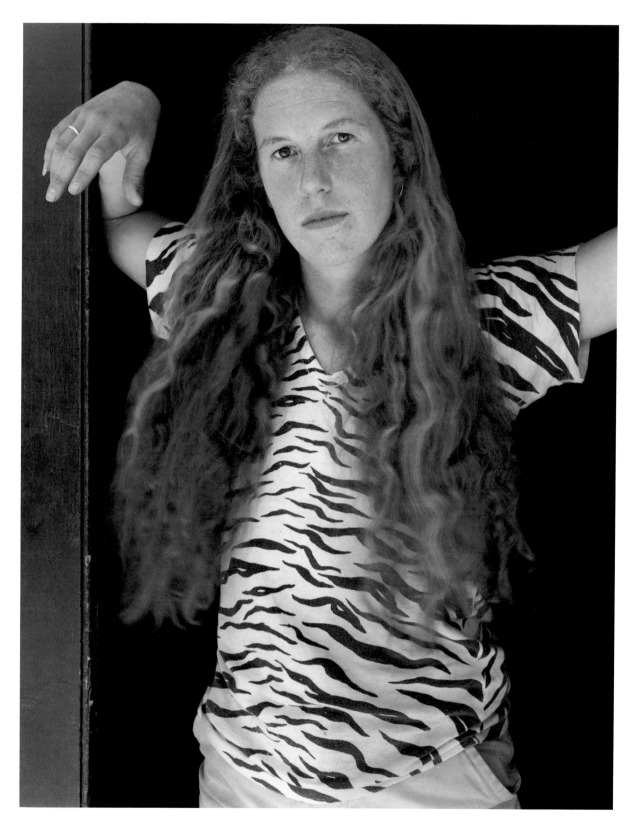

SUSIE, 1983 / PLATE 77

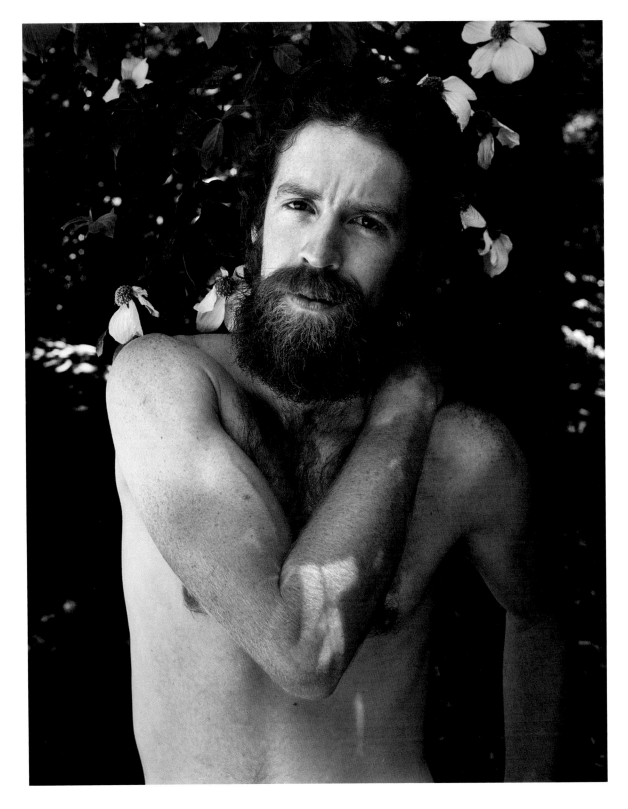

BILL, 1983 / PLATE 78

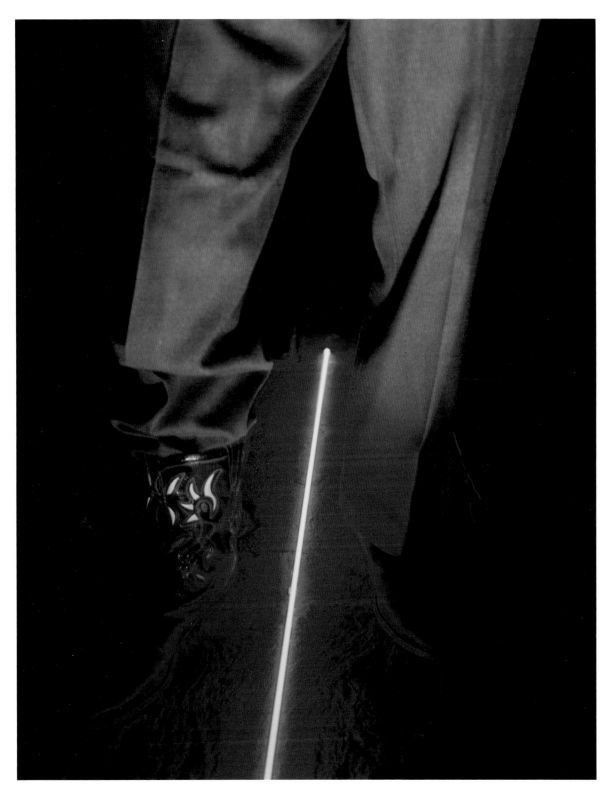

COWBOY BOOTS AND NEON, 1979 / PLATE 47

FOURTH OF JULY, NO. 1, 1984 / PLATE 85

EGYPT

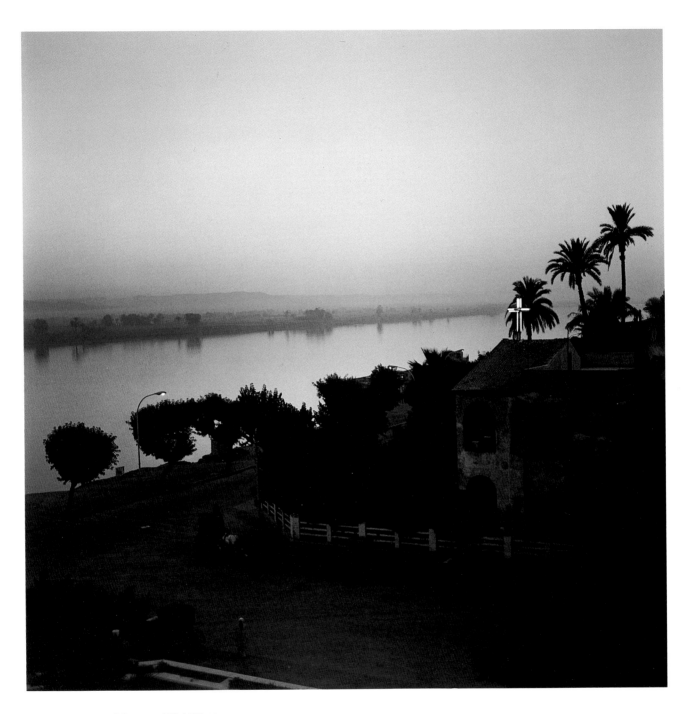

FIVE A.M., LUXOR, 1979 / PLATE 48

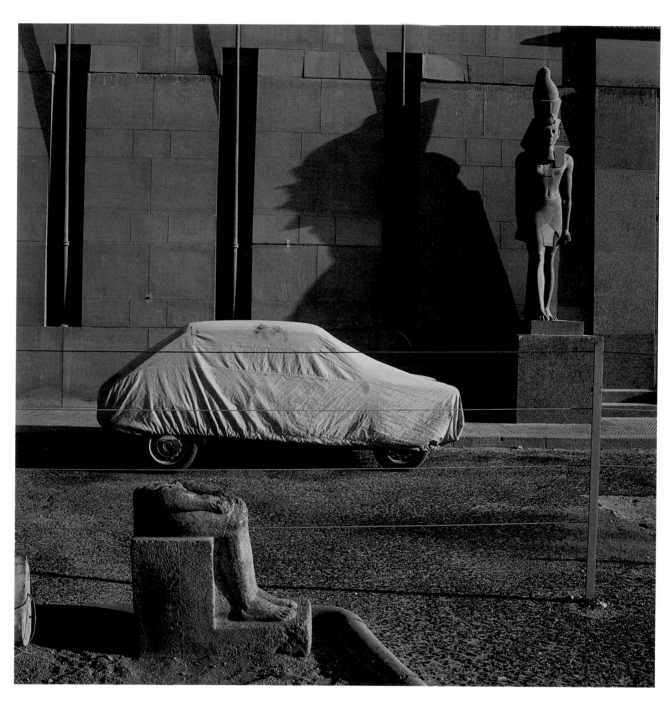

COVERED CAR, 1979 / PLATE 49

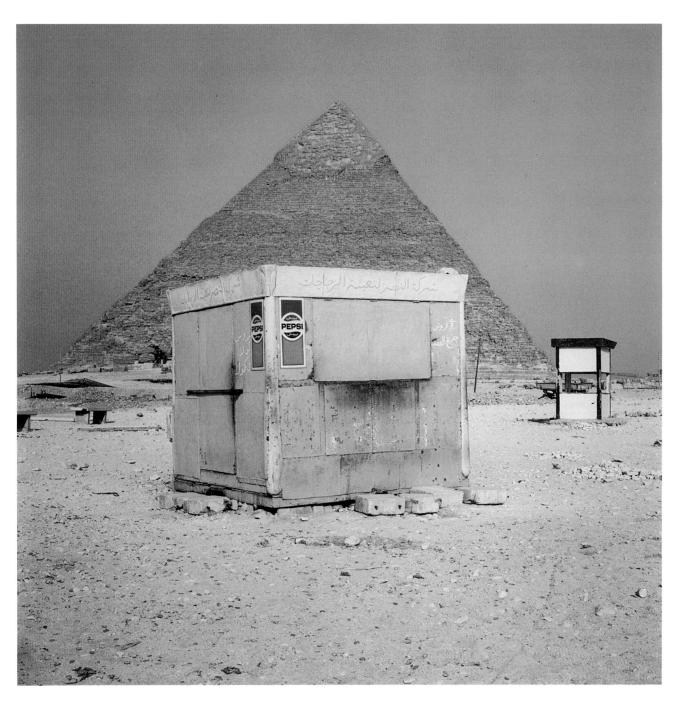

PEPSI STAND AND PYRAMID, 1979 / PLATE 52

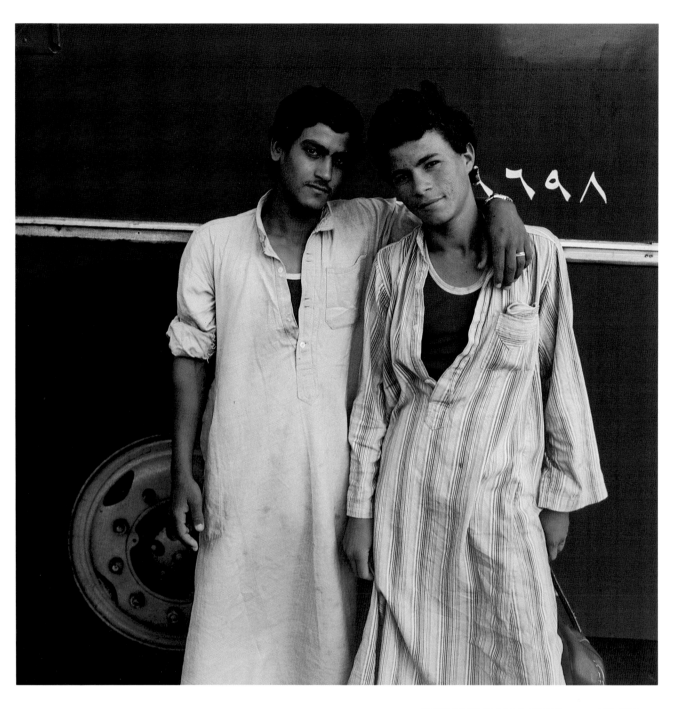

TWO YOUNG MEN, CAIRO, 1979 / PLATE 54

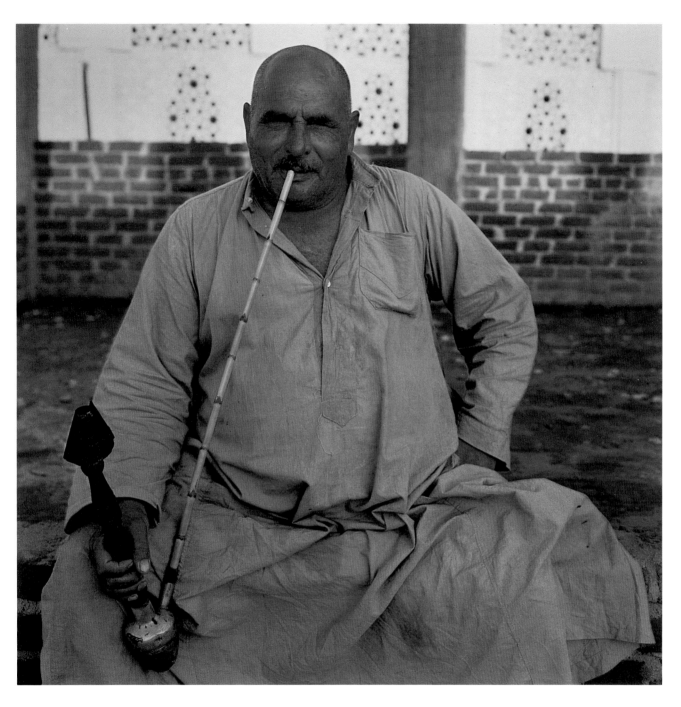

MAN WITH WATER PIPE, CAIRO, 1979 / PLATE 51

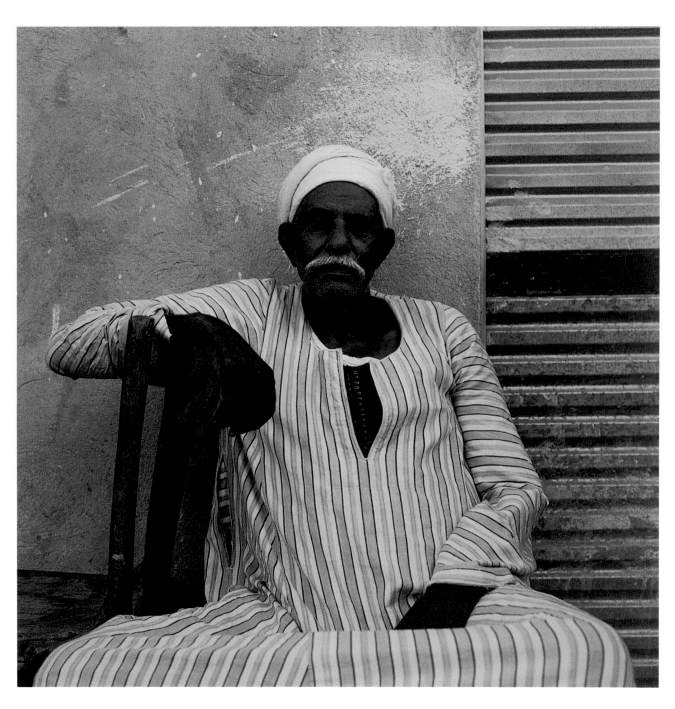

MAN IN WHITE TURBAN, 1979 / PLATE 50

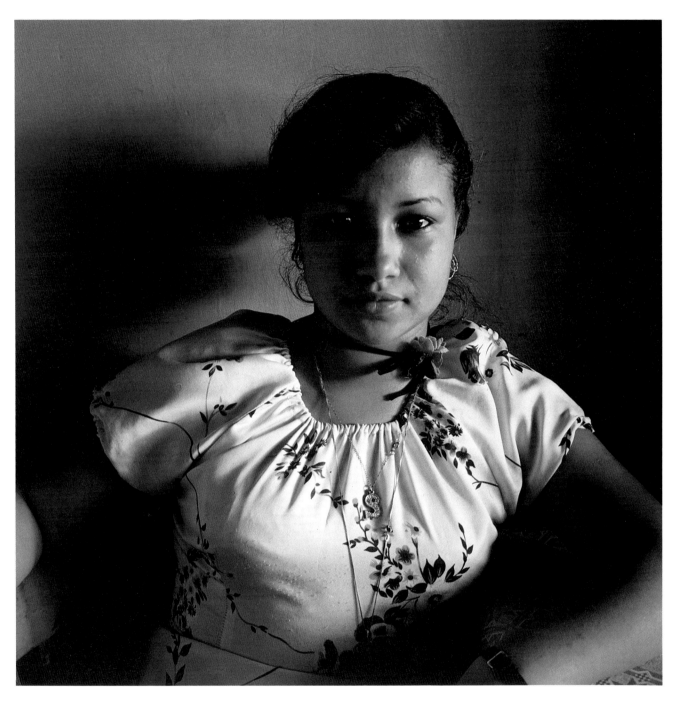

YOUNG WOMAN IN PINK DRESS, CAIRO, 1979 / PLATE 55

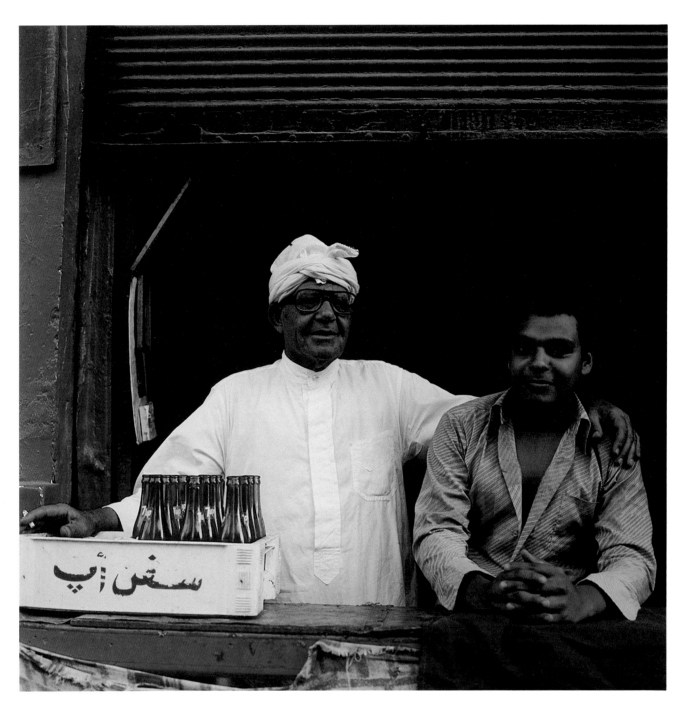

SEVEN-UP VENDORS, CAIRO, 1979 / PLATE 53

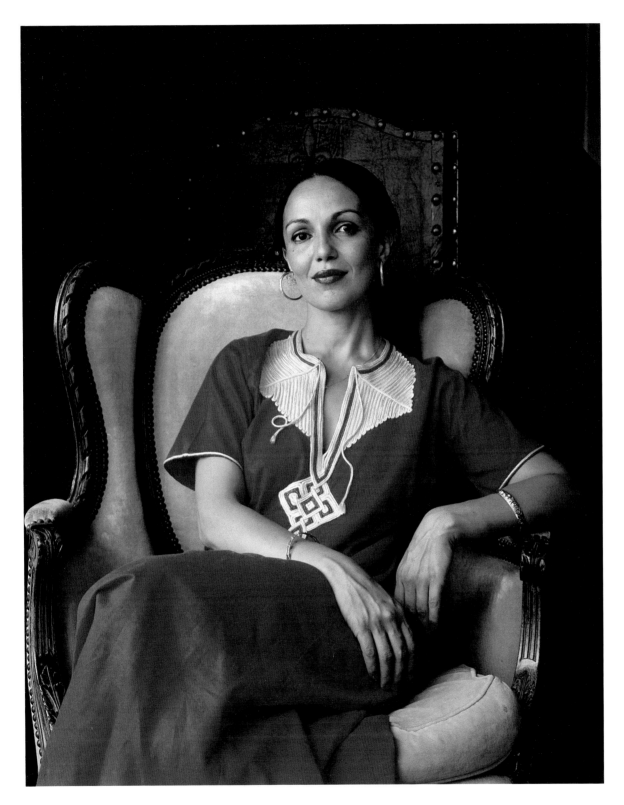

NAZLI RIZK, 1980 / PLATE 59

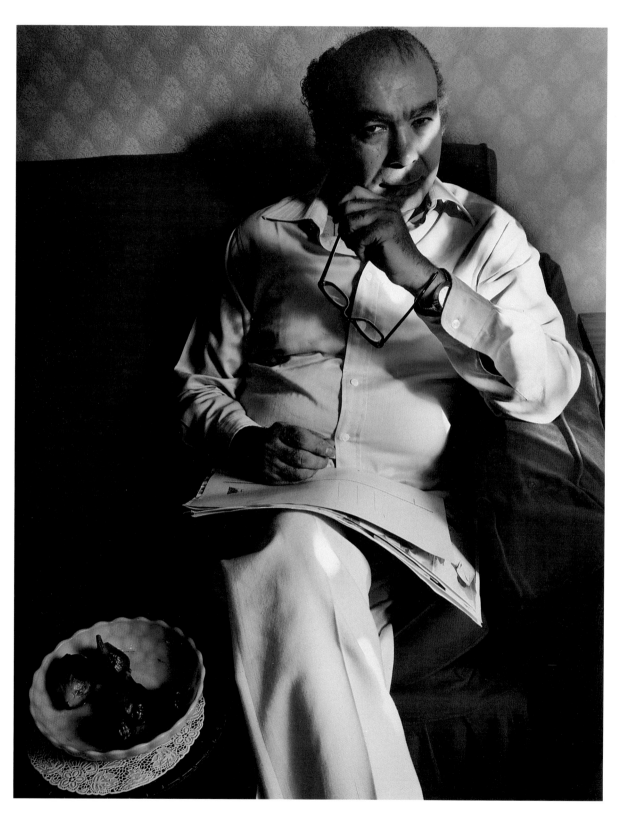

KAMAL EL MALLAKH, 1980 / PLATE 57

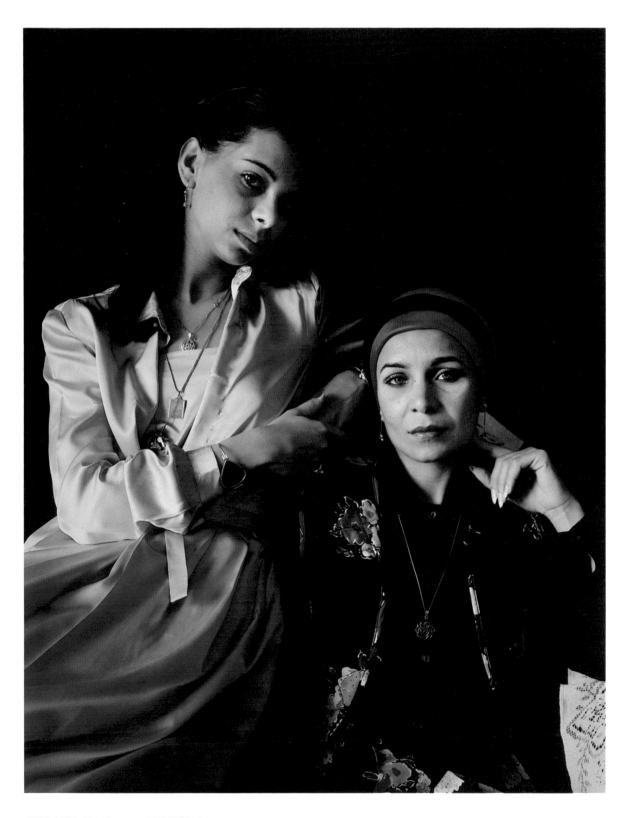

INIS AND AMAL, 1980 / PLATE 58

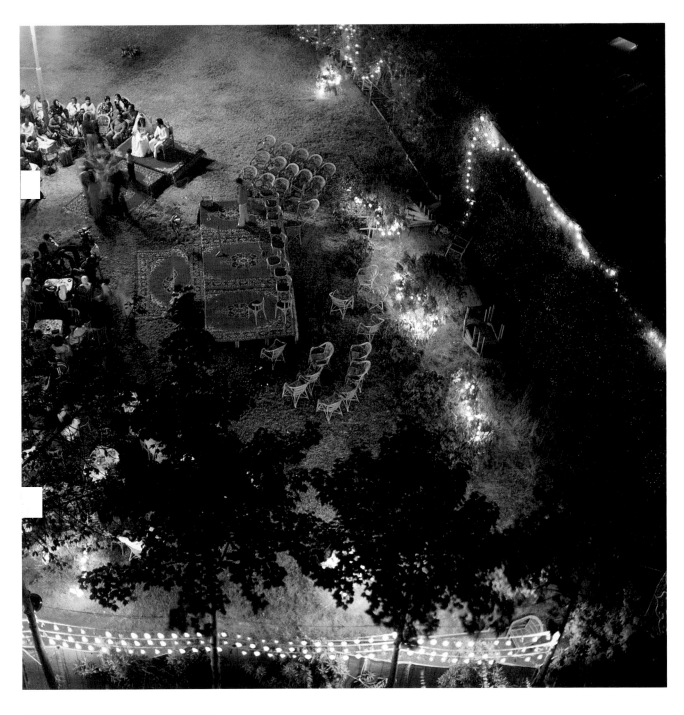

WEDDING, CAIRO, 1979 / PLATE 56

SELF-PORTRAITS

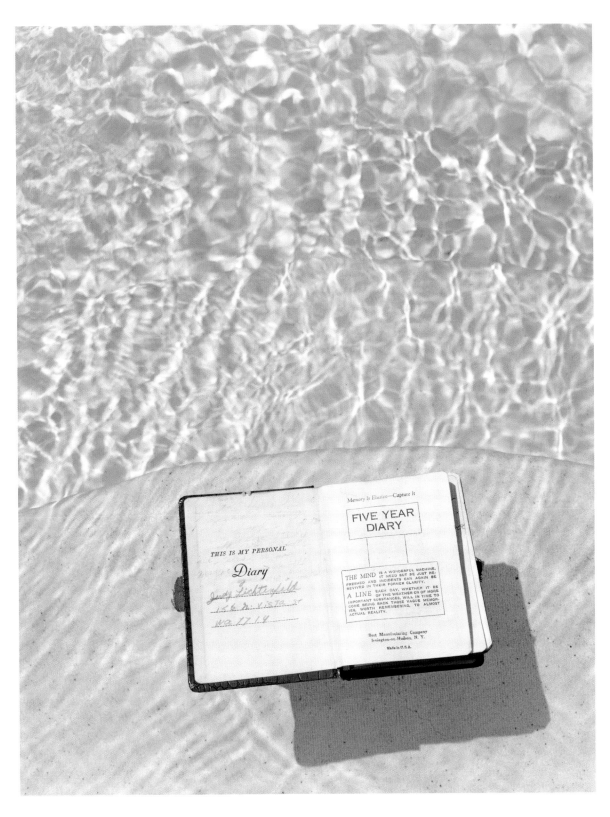

EXCERPTS FROM TEENAGE DIARY, NO. 2, 1982 / PLATE 76

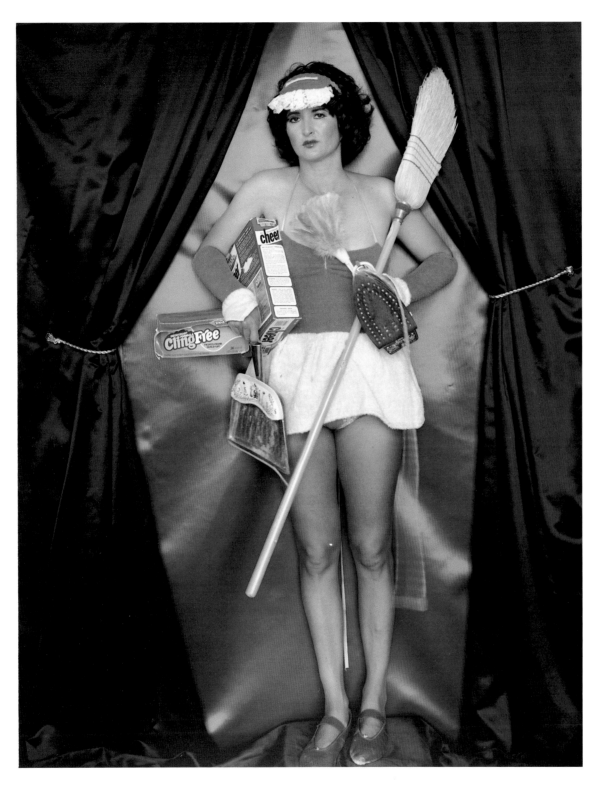

MS. CLINGFREE, 1982 / PLATE 70

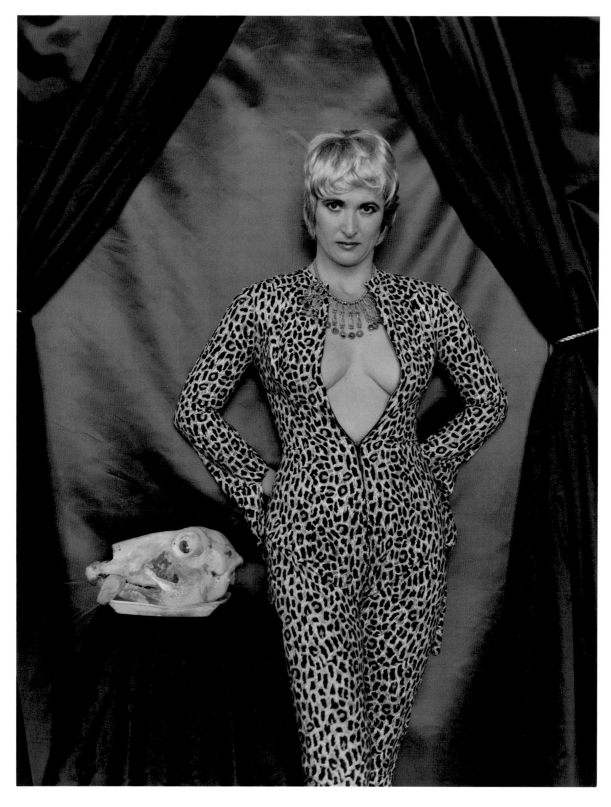

LEOPARD WOMAN, 1982 / PLATE 71

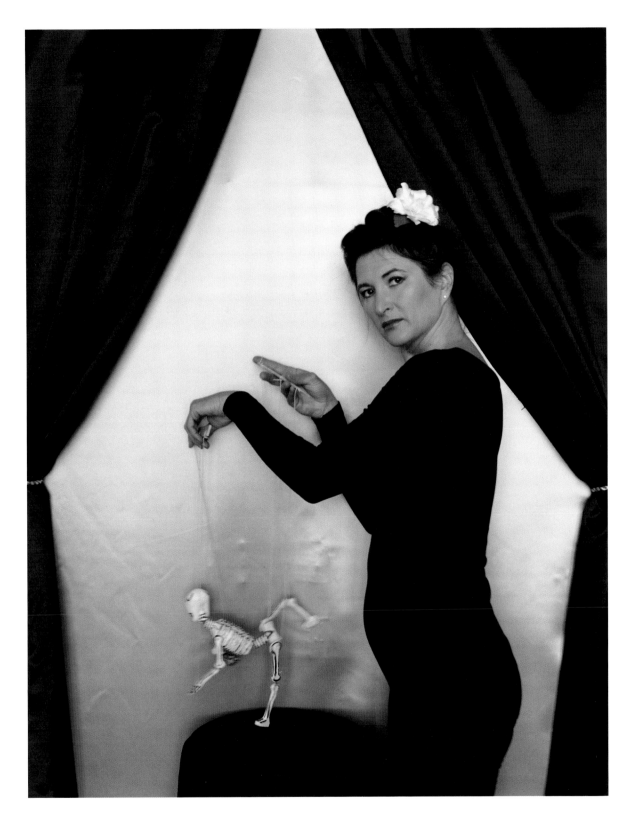

THE MAGICIAN, 1982 / PLATE 72

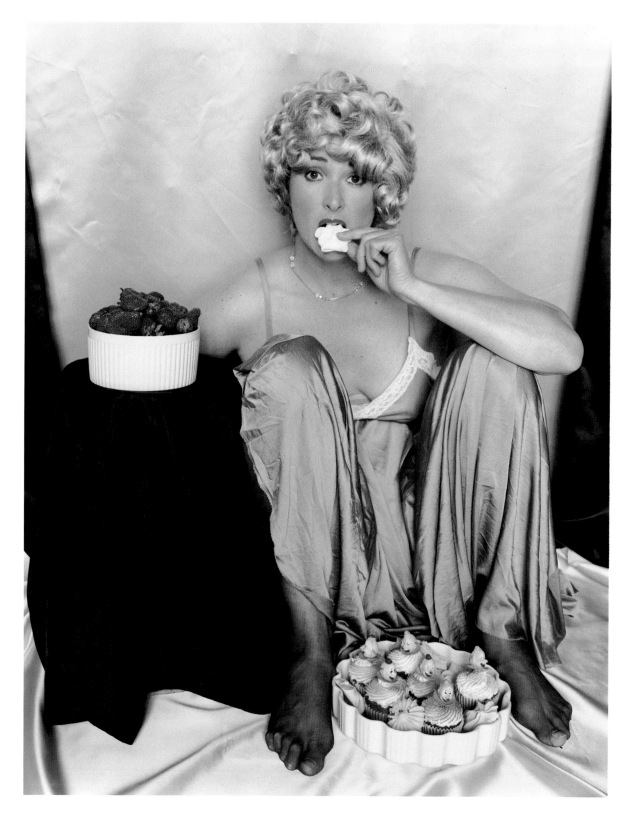

EATING, 1982 / PLATE 73

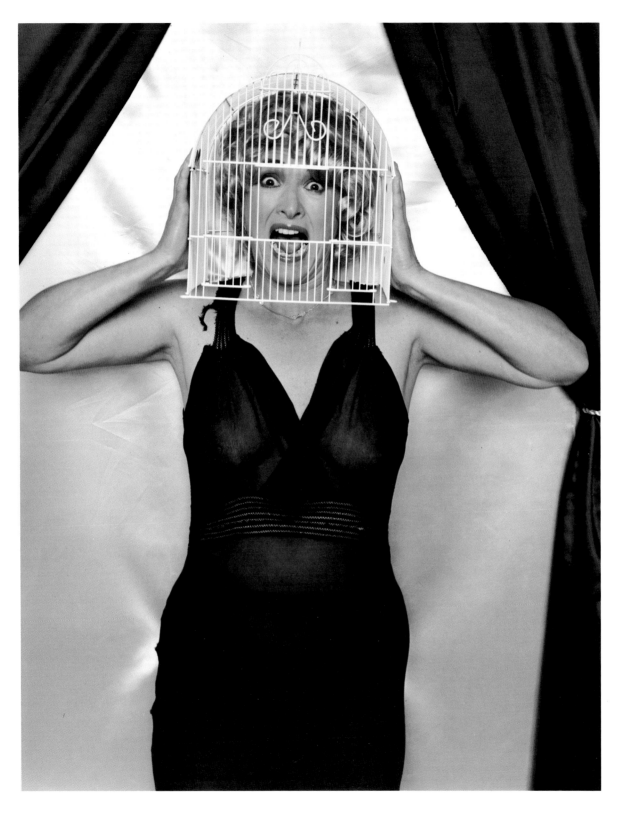

SCREAM, 1982 / PLATE 74

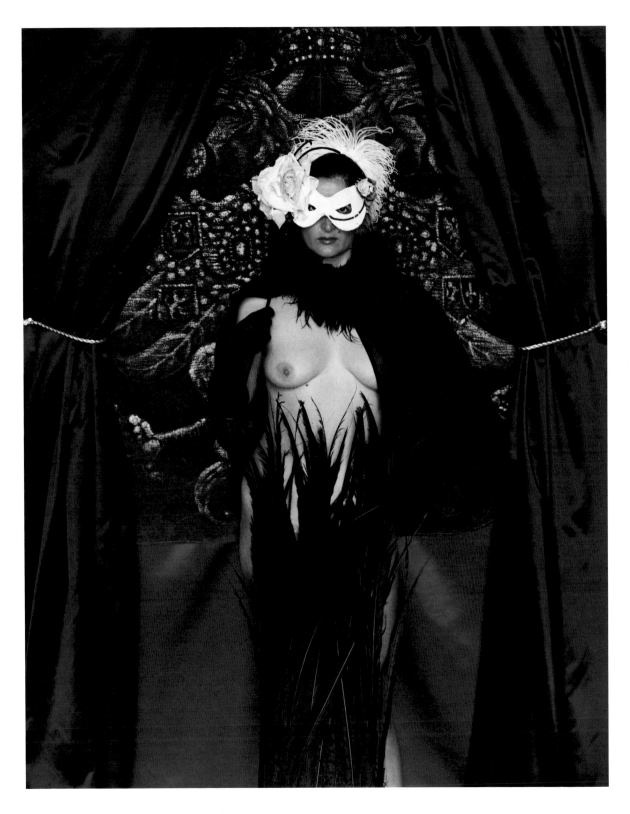

QUEEN OF THE NIGHT, 1982 / PLATE 75

I took a job at a small mid-western art school for five weeks as a guest artist. They gave me two dorm rooms as my living accommodations. One room was the bedroom. It had two single beds, a large work table, a stool, one chair, a chest of drawers, a small table with a telephone and radio on it, and a color TV. There were venetian blinds on the one window. One of the doors did not lock. The large work table was pushed up against this door, which made me feel better at night. They provided towels and linen for the bed.

My second room had a closet and another chest of drawers with a mirror over it. There was a desk along one wall with more drawers and shelves. One chair was at the desk and another chair in a corner. Under the one window with the same venetian blinds was a plaid couch. In front of the couch was a hemp rug, about five by seven feet with a round turquoise blue mosaic table on it. A basket of fruit was on the table when I first moved in. It contained one grapefruit, two oranges, two red apples and one green apple. My favorite part of the room was a small cubby-hole which had a hot plate with a tea kettle on it and a tiny refrigerator, a twenty four inch cube.

Every morning I would get up and use the bathroom, which was down the hall. My two rooms were on the same floor as the liberal arts offices. People would start coming in as early as 7:15 AM. I always tried to beat the first arrival to the bathroom. I would take the tea kettle with me, fill it with water, and then return to my rooms. Usually I would go

RainbowBlues LS=1 PAGE 1 LINE 1 CHAR 2 REPLACE < 13:58 > ●

SOMEWHERE OVER THE RAINBOW BLUES, 1985 / PLATE 86

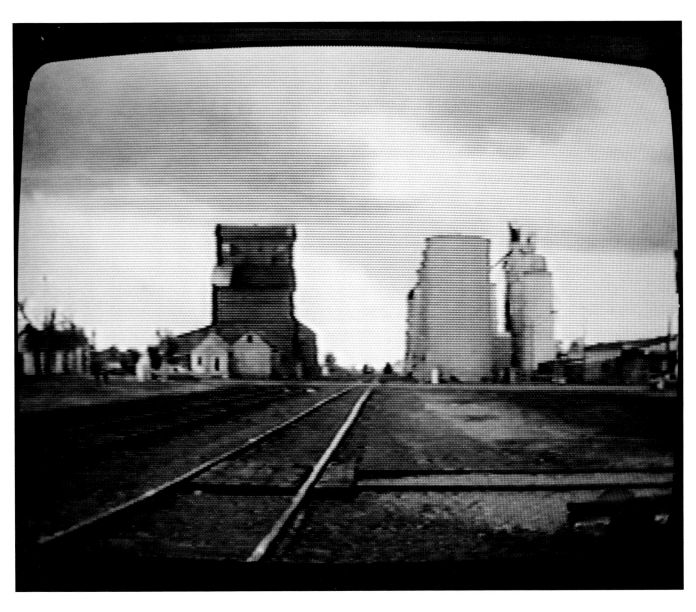

SOMEWHERE OVER THE RAINBOW BLUES, 1985 / PLATE 87

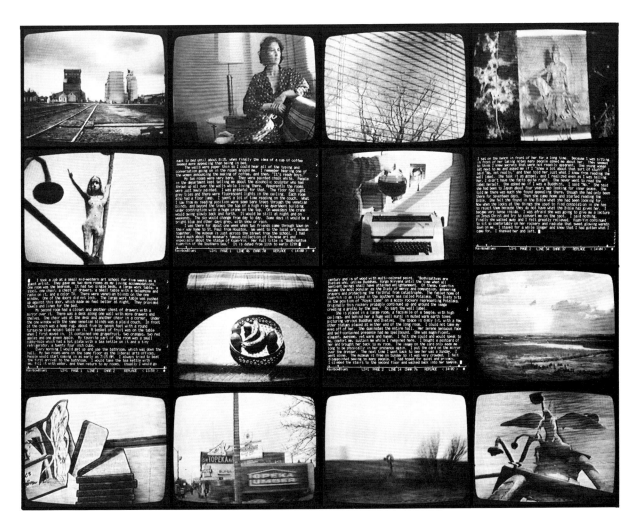

SOMEWHERE OVER THE RAINBOW BLUES, 1985 / PLATE 88

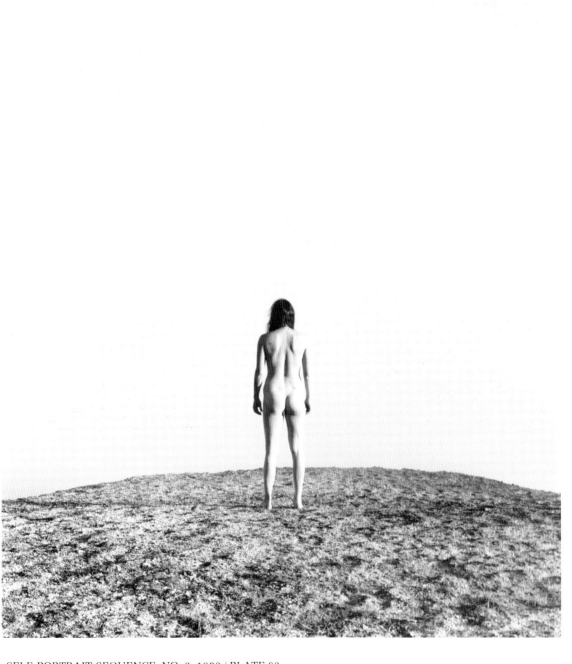

SELF-PORTRAIT SEQUENCE, NO. 2, 1982 / PLATE 63

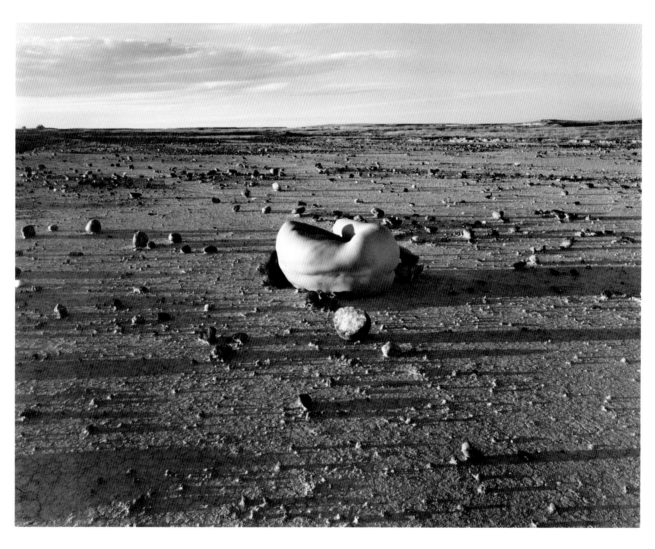

SELF-PORTRAIT SEQUENCE, NO. 3, 1982 / PLATE 64

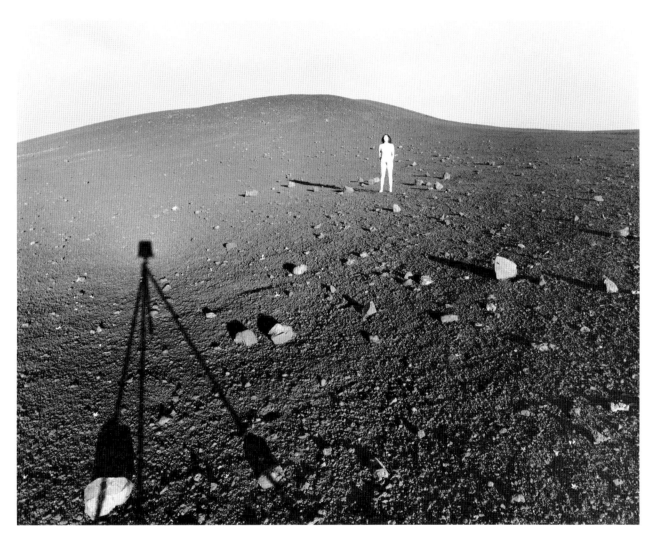

SELF-PORTRAIT SEQUENCE, NO. 4, 1982 / PLATE 65

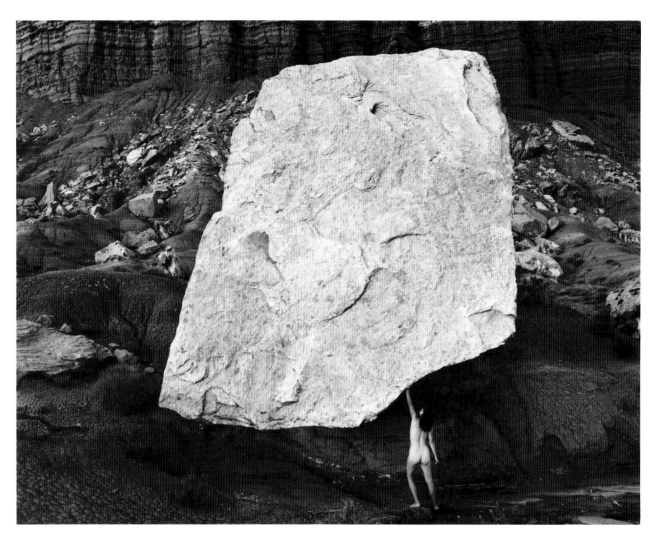

SELF-PORTRAIT SEQUENCE, NO. 6, 1982 / PLATE 66

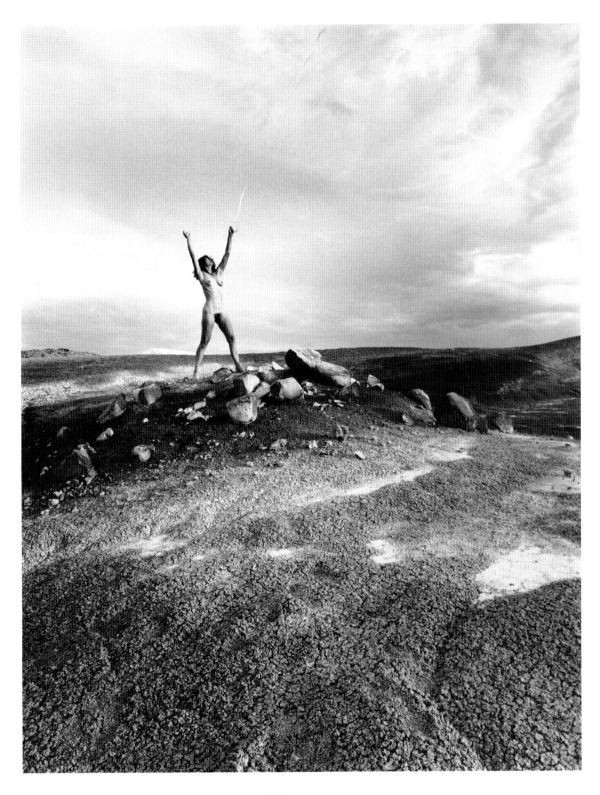

SELF-PORTRAIT SEQUENCE, NO. 5, 1982 / PLATE 67

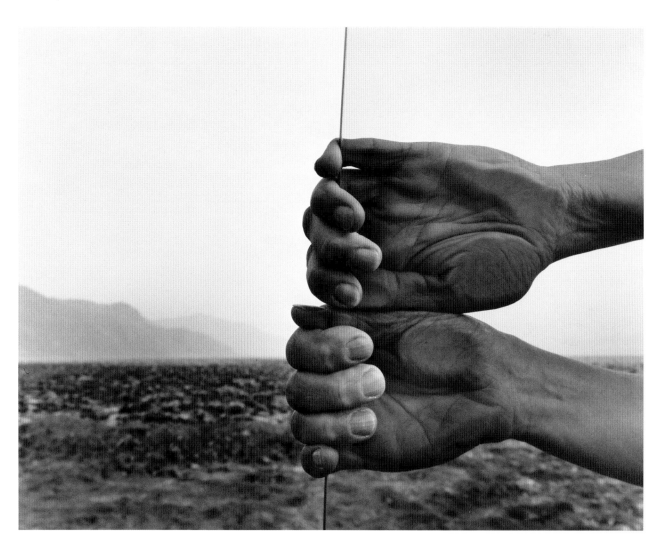

SELF-PORTRAIT SEQUENCE, NO. 1, 1982 / PLATE 68

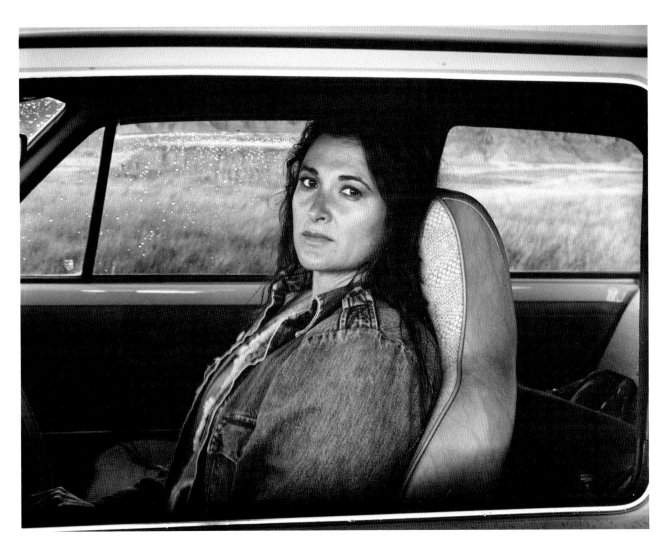

SELF-PORTRAIT SEQUENCE, NO. 7, 1982 / PLATE 69

NEW PORTRAITS

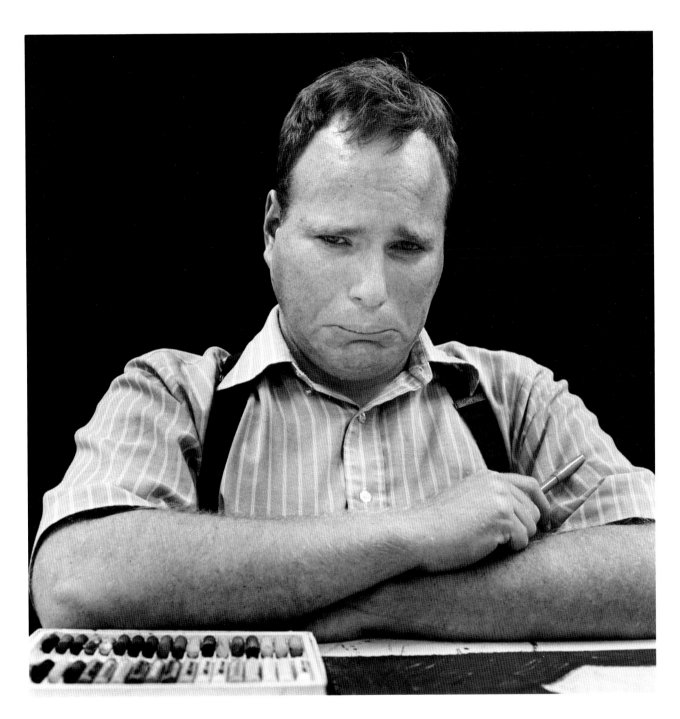

MAN WITH PASTELS, 1984 / PLATE 79

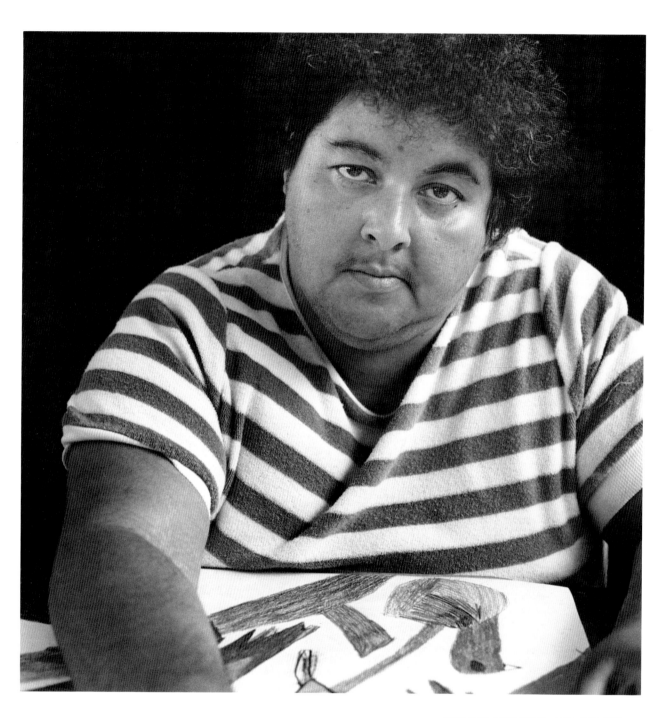

WOMAN AND BIRD, 1984 / PLATE 80

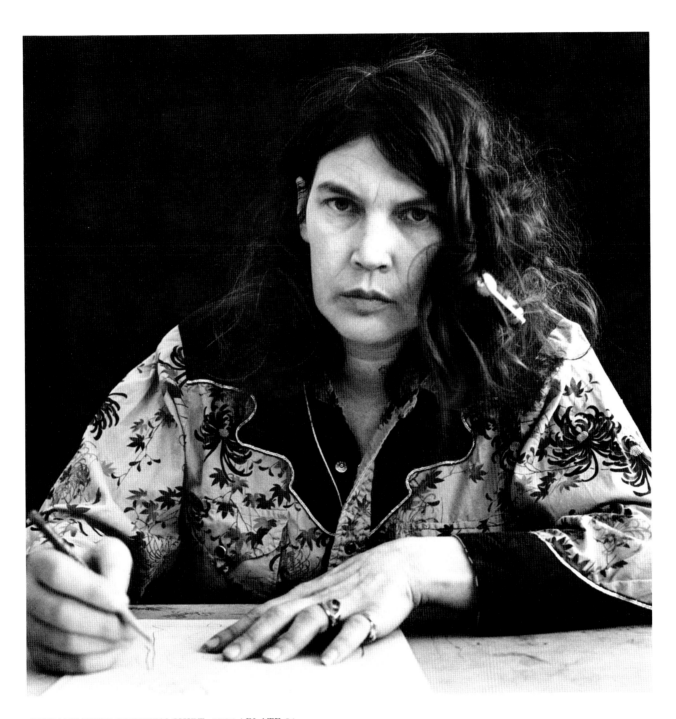

WOMAN WITH WESTERN SHIRT, 1984 / PLATE 81

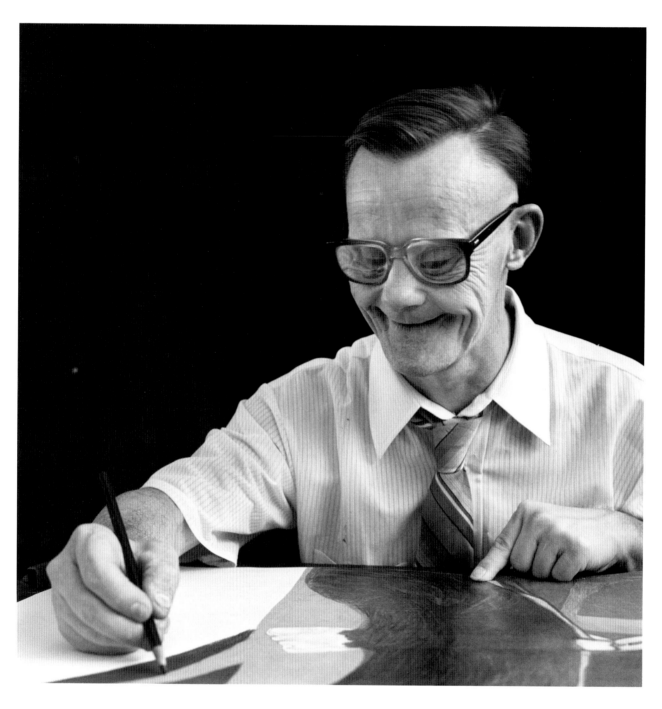

MAN WITH PENCIL, 1984 / PLATE 82

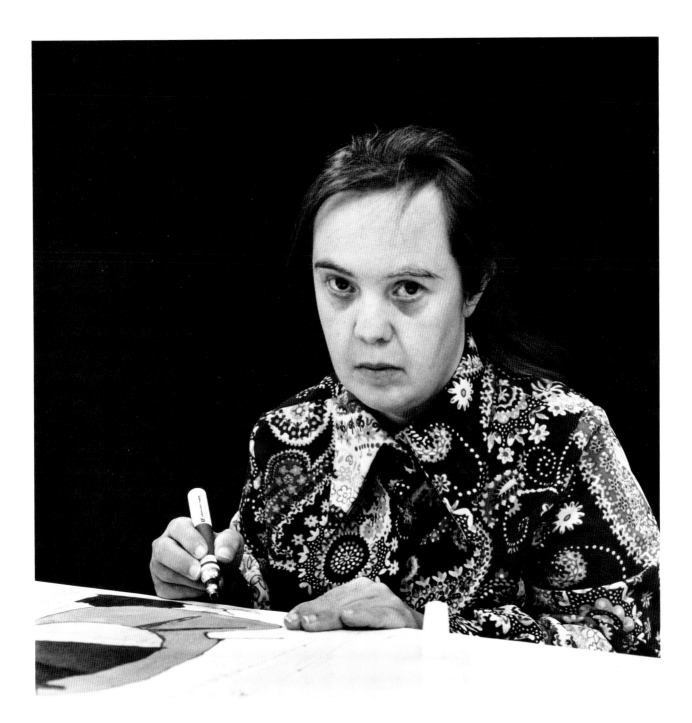

WOMAN DRAWING, 1984 / PLATE 83

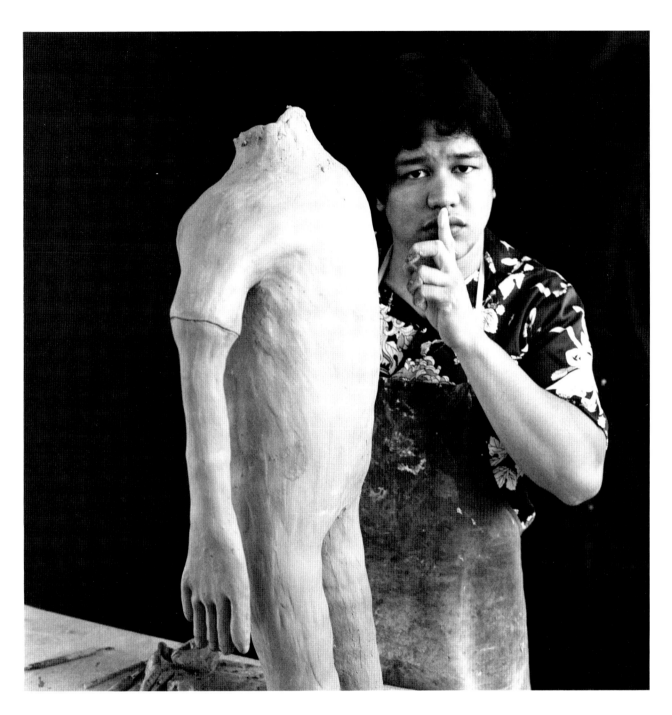

SCULPTOR, 1984 / PLATE 84

CHRONOLOGICAL
CHECKLIST OF PLATES

Plate 1 / Alabaster Bust, 1964 (page 3)
 8 x 10 silver print
 Lent by the artist

Plate 2 / Anna, 1964 (page 4)
 8 x 10 silver print
 Lent by the artist

Plate 3 / Lovers, 1964 (page 8)
 4¾ x 6 silver print
 Lent by the artist

Plate 4 / Siechi, 1964 (page 9)
 8 x 10 silver print
 Lent by the artist

Plate 5 / Dead Deer, 1966 (page 6)
 8 x 10 silver print
 Lent by the artist

Plate 6 / Woman from the Marshall Hotel, 1966 (page 55)
 8 x 10 silver print
 Lent by the Center for Creative Photography,
 University of Arizona

Plate 7 / At Napoleon's Tomb, Paris, 1967 (page 7)
 4½ x 7 silver print
 Lent by the Center for Creative Photography,
 University of Arizona

Plate 8 / Valerie Duval, 1969 (page 53)
 8 x 10 silver print
 Lent by the Center for Creative Photography,
 University of Arizona

Plate 9 / Joyce Goldstein, 1969 (page 50)
 16 x 20 silver print
 Lent by the artist

Plate 10 / Sharon Moore, 1970 (page 54)
 8 x 10 silver print
 Lent by the artist

Plate 11 / Twinka Thiebaud, Actor, Model, Writer, 1970
 (page 43)
 16 x 20 silver print
 Lent by the artist

Plate 12 / Maggie Wells, Painter, 1970 (page 49)
 16 x 20 silver print
 Lent by the artist

Plate 13 / Imogen's Things, 1971 (page 2)
 8 x 10 silver print
 Lent by the artist

Plate 14 / Imogen Cunningham, 1971 (page 39)
 8 x 10 silver print
 Lent by the artist

Plate 15 / Libby, 1971 (page 48)
 11 x 14 silver print
 Lent by the artist

Plate 16 / Maria and Legend, 1971 (page 40)
 8 x 10 silver print
 Lent by the artist

Plate 17 / Susan Remy, 1971 (page 52)
 11 x 14 silver print
 Lent by the Center for Creative Photography,
 University of Arizona

Plate 18 / Janet Stayton, Painter, 1971 (page 51)
 11 x 14 silver print
 Lent by the artist

Plate 19 / Aarmour Starr, 1972 (page 17)
 11 x 14 silver print
 Lent by the artist

Plate 20 / Gwen, 1972 (page 37)
 11 x 14 silver print
 Lent by the artist

Plate 21 / Kathleen and China, 1972 (page 41)
8 x 10 silver print
Lent by the artist

Plate 22 / Kathleen Kelly, 1972 (page 35)
16 x 20 silver print
Lent by the artist

Plate 23 / Woman and Dog, Beverly Hills, 1972 (page 45)
11 x 14 silver print
Lent by the artist

Plate 24 / Daydreams, 1973 (page 13)
16 x 20 silver print
Lent by the Center for Creative Photography,
University of Arizona

Plate 25 / Laura Mae, 1973 (page 38)
16 x 20 silver print
Lent by the artist

Plate 26 / Sabine, 1973 (page 36)
11 x 14 silver print
Lent by the artist

Plate 27 / Imogen and Twinka, 1974 (page 47)
11 x 14 silver print
Lent by the artist

Plate 28 / Maria Theresa, 1974 (page 44)
11 x 14 silver print
Lent by the artist

Plate 29 / Harold Jones, 1975 (page 20)
16 x 20 silver print
Lent by the Center for Creative Photography,
University of Arizona

Plate 30 / Nehemiah (back view), 1975 (page 14)
11 x 14 silver print
Lent by the artist

Plate 31 / Nehemiah (front view), 1975 (page 15)
16 x 20 silver print
Lent by the artist

Plate 32 / Sandy, 1975 (page 31)
11 x 14 silver print
Lent by the artist

Plate 33 / Minor White, 1975 (page 33)
11 x 14 silver print
Lent by the artist

Plates 34 / Arles Suite, 1976–78 (pages 57 to 59)
& 35 Seven 16 x 20 silver prints
Lent by the Center for Creative Photography,
University of Arizona

Plate 36 / Stonecutter, Pietra Santa, Italy, 1976 (page 28)
11 x 14 silver print

Lent by the Center for Creative Photography,
University of Arizona

Plate 37 / Young Man, Tokyo, 1976 (page 26)
11 x 14 silver print
Lent by the artist

Plate 38 / Statue, Cross, and Hand, Italy, 1976 (page 5)
9 x 11½ silver print
Lent by the artist

Plate 39 / Ansel Adams, 1977 (page 23)
11 x 14 silver print
Lent by the artist

Plate 40 / Peter Bunnell, 1977 (page 25)
16 x 20 silver print
Lent by the artist

Plate 41 / Beaumont Newhall, 1977 (page 18)
11 x 14 silver print
Lent by the Center for Creative Photography,
University of Arizona

Plate 42 / Bernie, 1978 (page 30)
11 x 14 silver print
Lent by the artist

Plate 43 / Jim Hendrickson, 1978 (page 16)
11 x 14 silver print
Lent by the artist

Plate 44 / Hide, 1978 (page 29)
11 x 14 silver print
Lent by the artist

Plate 45 / Patrick Nagatani, 1978 (page 24)
16 x 20 silver print
Lent by the Center for Creative Photography,
University of Arizona

Plate 46 / John Szarkowski, 1978 (page 19)
16 x 20 silver print
Lent by the Center for Creative Photography,
University of Arizona

Plate 47 / Cowboy Boots and Neon, 1979 (page 65)
16 x 20 incorporated color coupler print
Lent by the artist

Plate 48 / Five A.M., Luxor, 1979 (page 71)
15 x 15 incorporated color coupler print
Lent by Wah Lui

Plate 49 / Covered Car, 1979 (page 72)
15 x 15 incorporated color coupler print
Lent by Wah Lui

Plate 50 / Man in White Turban, 1979 (page 76)
15 x 15 incorporated color coupler print
Lent by Wah Lui

SELECTED BIBLIOGRAPHY

Compiled by Stuart Alexander

BOOKS BY JUDY DATER

Imogen Cunningham: A Portrait. Boston: New York Graphic Society, 1979. 188 pp. [Includes edited interviews by Dater with forty friends, relatives, and acquaintances of Cunningham; 1 portrait of Cunningham and 32 portraits by Dater of people interviewed; 60 plates by Cunningham.]

Women and Other Visions: Photographs by Judy Dater and Jack Welpott. Introductory essay by Henry Holmes Smith. Dobbs Ferry, New York: Morgan & Morgan, 1975. [158 pp.] [52 b&w by Dater, 54 b&w by Welpott. Includes a statement by Welpott, chronologies for the two artists, and a portrait of them by Arnold Newman.]

BOOKS AND CATALOGUES

Ackley, Clifford S. *Private Realities: Recent American Photography.* Boston: Museum of Fine Arts, 1974. [94 pp.] [Dater discussed on p. 9; 4 b&w, biography, exhibitions list, and bibliography on pp. 68−75; 13 b&w on p. 94.]

Coleman, A. D. "Judy Dater." In *Light Readings: A Photography Critic's Writings, 1968−1978;* pp. 106−7. New York: Oxford University Press, 1979. 283 pp. [Exhibition review: "Judy Dater," Witkin Gallery, New York. Reprinted from *New York Times (4 June 1972), sect. 2, p. 16.*]

Contact: Theory. New York: Lustrum Press, 1980. 175 pp. [1 contact sheet, comment by Dater, and 1 b&w (Twinka, 1970) on pp. 20−23.]

"DATER Judy." Entry in *Contemporary Photographers,* pp. 179−80. Edited by George Walsh, Colin Naylor, and Michael Held. New York: St. Martin's Press, 1982. 837 pp. [Essay by Ted Hedgpeth; statement by Dater; 1 b&w (Nehemiah's Back); includes a brief chronology, exhibitions list, and bibliography.]

Friends and Strange Dreams: Photographs by Wah Lui. Introduction by Judy Dater. Interview by George Schaub. Seattle: Distant Thunder Press, 1984. 92 pp. [Introduction by Dater is on pp. 4−5; Dater mentioned as an influence on p. 11; 1 b&w portrait of Dater by Lui on p. 34.]

Green, Jonathan. *American Photography; A Critical History, 1945 to the Present.* New York: Harry N. Abrams, 1984. 247 pp. [1 b&w portrait on a baseball card by Mike Mandel on p. 6; 1 b&w (Minor White) on p. 101; 1 b&w in an illus. of the collaged front cover of *Newsweek* (21 October 1974) on p. 145; mentioned on p. 208.]

"Judy Dater." In *Darkroom 2*, pp. 7–23. Edited by Jain Kelly. New York: Lustrum Press, 1978. 160 pp. [Dater outlines her photographic technique; 2 portraits, 8 illus., 7 b&w, and 4 contact proof prints are reproduced; 9 other photographers discuss their techniques.]

"Judy Dater: The Feminine Eye." In *Photography Year 1973*, pp. 110–17. Edited by the Editors of Time-Life Books. New York: Time-Life Books, 1972. 234 pp. [7 b&w; 1 b&w on front cover; portrait on p. 107; mentioned on pp. 2, 108, 109.]

Katzman, Louise. *Photography in California, 1945–1980*. Introduction by Van Deren Coke. New York: Hudson Hills Press, in association with the San Francisco Museum of Modern Art, 1984. 205 pp. [1 color (Leopard Woman) is frontispiece: 1 b&w (Cheri) on p. 78; 1 color (Eating) on p. 79; 1 color (Ms. Clingfree) on p. 80; quoted on p. 94; briefly discussed on pp. 12, 82; mentioned on pp. 47, 48, 49, 56, 57; 5 photographs listed on p. 182; brief biography on p. 190.]

Maddow, Ben. *Faces: A Narrative History of the Portrait in Photography*. Photographs compiled and edited by Constance Sullivan. Boston: New York Graphic Society, A Chanticleer Press Edition, 1977. 540 pp. [1 b&w (Maureen, 1972) on p. 472; 1 b&w (Tony, 1972) on p. 473; discussed on pp. 468–69.]

Mann, Margery, and Anne Noggle. *Women of Photography: An Historical Survey*. San Francisco: Museum of Art, 1975. [128 pp.] [1 b&w (Laura Mae), commentary, and 5 b&w listed on pp. 102–3.]

Markowski, Gene. *The Art of Photography: Image and Illusion*. Englewood Cliffs, New Jersey: Prentice-Hall, 1984. [1 b&w (Twinka, Crouching) on p. 83 and discussed on pp. 82–83; 1 b&w (Self-Portrait with Rock) on p. 103 and discussed on pp. 102–3.]

Photo Facts and Opinions. Edited by Kelly Wise. Andover, Mass.: The Addison Gallery of American Art, Phillips Academy, 1981. 44 pp. [A letter by Dater about her photography and her estimation of contemporary photography on pp. 20–21.]

Rosenblum, Naomi. *A World History of Photography*. New York: Abbeville Press, 1984. 671 pp. [1 b&w (Laura Mae, 1973) on p. 550, discussed on p. 555.]

Witkin, Lee D., and Barbara London. *The Photograph Collector's Guide*. Boston: New York Graphic Society, 1979. 438 pp. [Judy Dater entry on pp. 119–120 includes 1 b&w, brief biography, facsimile signature, and a bibliography. Dater mentioned on p. 221, quoted on p. 267; 1 illus. of the cover of her portfolio, *Ten Photographs*, on p. 276; information about this portfolio on p. 282.]

The Woman's Eye. Edited and with an introduction by Anne Tucker. New York: Alfred A. Knopf, A Collins Associate Book, 1973. 170 pp. [1 b&w (Twinka) on front cover; mentioned on p. 1; discussed on pp. 8, 10–11, 141–43; portrait by J. Welpott on p. 142; 10 b&w by Dater on pp. 144–153.]

PERIODICALS

Asbury, Dana. "Shows We've Seen: Two Views of Landscapes, by Gail Skoff and Judy Dater." *Popular Photography* 90:2 (February 1983), p. 37. [1 b&w by Dater, 1 color by Skoff. Exhibition review: "Gail Skoff, Judy Dater," Santa Fe Center for Photography, Santa Fe, New Mexico.]

Coleman, A. D. "Photography: Spirit Photographs: Are They All Hoaxes?: Dater Show." *New York Times* (4 June 1972), sect. 2, p. 16. [Exhibition review: "Judy Dater," Witkin Gallery, New York.]

"Dater." *Camera* 49:4 (April 1970), pp. 16–23. [6 b&w. Includes brief statement by Dater; mentioned on p. 47.]

Davis, Douglas. "The Ten 'Toughest' Photographs of 1975." *Esquire* 85:2 (February 1976), pp. 108–15, 150–51. [1 b&w (Imogen and Twinka) on p. 108, discussed on p. 109; 7 b&w, 2 color by various other photographers.]

Enyeart, James L. "Acquisitions Highlight: Judy Dater." *The Archive*, no. 14 (December 1981), pp. 40–43. [1 color (Wedding Cairo, 1979); discussed in context of her color work in Egypt and in relation to all her work.]

Fahey, David. "Judy Dater: Interview." *G. Ray Hawkins Gallery Photo Bulletin* 2:8 (December 1979), [pp. 1–5]. [6 b&w.]

Fischer, Hal. "Photography: Judy Dater." *Artweek* (11 October 1975), pp. 11–12. [2 b&w. Exhibition review: "Judy Dater," Oakland Museum, Oakland, California.]

Fischer, Hal. "Reviews: San Francisco: Judy Dater." *Artforum* 17:5 (January 1979), pp. 70–71. [1 b&w (Marc). Exhibition review: "Judy Dater," Grapestake Gallery, San Francisco.]

Fischer, Hal. "Special Issue; Northern California Photography." *Picture*, no. 11 (April/May 1979), [pp. 1–32]. [4 b&w by Dater on pp. 13–16; discussed on p. 21. 12 b&w, 8 color by various other photographers.]

Grundberg, Andy. "Review of Books: Photography: Women and Other Visions." *Art in America* 64:1 (January/February 1976), pp. 29, 31. [Book review: *Women and Other Visions: Photographs by Judy Dater and Jack Welpott.*]

"Judy Dater." *Place* 3:1 (June 1973), pp. 144–52. [8 b&w. Includes a poem by Dater.]

Lifson, Ben. "Photography: Cheap Thrills and a Little Thought." *Village Voice* 24:5 (29 January 1979), p. 69. [1 b&w by Don Rodan, 1 b&w (Maggi) by Dater. Exhibition reieves: "The Greek Myth: Don Rodan," Castelli Graphics, New York; "Judy Dater," Witkin Gallery, New York; "David Haxton," Sonnabend Gallery, New York.]

"Making Contact: How Do Photographers Choose One Image Over Another?" *Modern Photography* 45:5 (May 1981), pp. 94–99. [Adapted from the book: *Contact: Theory*. 1 b&w (Twinka); 1 contact sheet by Dater on pp. 96–97. Other photographers in article are Elliot Erwitt and Martine Franck.]

Mowbray, Clare. "Interview: Conversation with Judy Dater." *Photographer's Forum* 3:4 (September 1981), pp. 30–38. [1 portrait, 7 b&w.]

Murray, Joan. "Photography: Judy Dater's Studies of Men and Women." *Artweek* 9:39 (18 November 1978), p. 11. [2 b&w. Exhibition review: "Judy Dater," Grapestake Gallery, San Francisco.]

Phillips, Donna-Lee. "Personas of Women." *Artweek* (31 March 1984), pp. 15–16. [2 b&w of color originals (Leopard Woman), (Ms. Clingfree). Exhibition review: "Judy Dater: A Personal View," Grapestake Gallery, San Francisco.]

Pretzer, Michael. "Regional Reviews: Rhode Island." *Art New England* 1:7 (June 1980), p. 16. [1 b&w. Exhibition review: "Imogen Cunningham and Judy Dater, Photographs," JEB Gallery, Providence, Rhode Island.]

Rice, Shelley. "Portfolio," *Ms.* 6:12 (June 1978), pp. 42–43. [2 b&w (Nehemiah's Back), (Laura Mae).]

Senti, Richard. "Masters of Photography: The Many Faces of Judy Dater." *Darkroom Photography* 5:7 (November 1983), pp. 22–25, 27–31. [Interview. 1 color (Ms. Clingfree) on front cover; 3 color (Eating), (Spider Woman), (Leopard Woman); 1 b&w (Self-portrait, 1983); 1 portrait by Senti. See also "Editor's Page," on p. 4.]

Sobieszek, Robert A. "Ms.: Portraits of Women by Judy Dater and Jack Welpott." *Image* 16:1

(March 1973), pp. 11–12. [1 b&w by Dater, 1 b&w by Welpott. Article includes a letter from Dater and Welpott about their portraits of women.]

Thornton, Gene. "Photography: Is There Really a Difference?" *New York Times* (April 14, 1974), sect. 2, p. 30. [1 b&w by Jack Welpott. Exhibition review: "Judy Dater and Jack Welpott," Witkin Gallery, New York.]

Welpott, Jack. "Judy Dater & Jack Welpott: A Collaboration." *Untitled*, no. 7/8 (1974), pp. 34–39. [2 b&w by Dater, 2 b&w by Welpott. Includes a statement about their portrait work signed by Welpott.]

Williams, Alice. "What Price Fame? An Informal Survey of 13 Photographers Who've Paid the Price." *35mm Photography* (Winter 1978), pp. 6–7, 10, 12, 14, 16, 18, 120. [Judy Dater's response is on p. 18.]

FILM ABOUT DATER

The Woman Behind the Image: Photographer Judy Dater. John Stewart Productions. 16 millimeter, color/sound, 27 minutes, ca. 1981.

PORTFOLIOS

Judy Dater: Ten Photographs. Introduction by Jack Welpott. Roslyn Heights, New York: Witkin-Berley Limited, 1973. 10 prints (7″ x 9″ and 10″ x 13″) mounted on 16″ x 20″ board. Edition of 25 plus 7 artist's proofs.

Judy Dater: Men/Women, Portfolio II. Berkeley, California: Collected Visions, Inc., 1981. Edition of 60.

SELECTED ONE-PERSON EXHIBITIONS

1972 Witkin Gallery, New York
 University of Maryland, Baltimore

1973 University of Colorado, Boulder
 Center for Photographic Studies, Louisville, Kentucky
 George Eastman House, Rochester, New York [With Jack Welpott]
 Focus Gallery, San Francisco [With Jack Welpott]

1974 Oakland Museum, Oakland, California
 Witkin Gallery, New York [With Jack Welpott]

1975 Spectrum Gallery, Tucson, Arizona
 Silver Image Gallery, Seattle, Washington
 Shadai Gallery, Tokyo [With Jack Welpott]
 Washington Gallery of Photography, Washington D.C. [With Jack Welpott]

1976 Evergreen State College, Olympia, Washington
 Galerie Fiolet, Amsterdam [With Jack Welpott]
 Musée Réattu, Arles, France [With Jack Welpott]
 Enjay Gallery, Boston [With Jack Welpott]

1977 Grapestake Gallery, San Francisco
 Susan Spiritus Gallery, Newport Beach, California

1978 Witkin Gallery, New York

1979 G. Ray Hawkins Gallery, Los Angeles
Yuen Lui Gallery, Seattle, Washington
Kimball Art Center, Park City, Utah
Contemporary Arts Center, New Orleans

1980 JEB Gallery, Providence, Rhode Island
Photography Southwest Gallery, Scottsdale, Arizona

1981 Atlanta Gallery, Atlanta, Georgia
Camera Obscura Gallery, Denver
Orange Coast College, Costa Mesa, California
University of North Dakota Art Gallery, Grand Forks

1982 Kathleen Ewing Gallery, Washington, D.C.
Burton Gallery, Toronto
Spectrum Gallery, Fresno, California
"Girls of the Golden West," Santa Fe Center for Photography [With Gail Skoff]

1983 North Carolina State University, Raleigh
Victor Hasselblad Aktiebolag Gallery, Goteborg, Sweden
University Art Museum, University of Oregon, Eugene
The Photographic Center, Dallas, Texas

1984 Grapestake Gallery, San Francisco
Kathleen Ewing Gallery, Washington, D.C.
"Portraits of Disabled Artists," San Francisco Museum of Modern Art
Yuen Lui Gallery, Seattle, Washington

1985 Northern Arizona University Art Gallery, Flagstaff

SELECTED GROUP EXHIBITIONS
(All of the following unless otherwise indicated, were accompanied with a catalogue that
contains at least one reproduction of a Judy Dater photograph.)

1967 "Photography U.S.A.," De Cordova Museum, Lincoln, Massachusetts

1968 "Light 7," Hayden Gallery, Massachusetts Institute of Technology, Cambridge

1969 "Vision and Expression," George Eastman House, Rochester, New York
"Visual Dialogue Foundation," Center of the Visual Arts, Oakland, California

1970 "California Photographers 1970," Memorial Union Art Gallery, University of California,
Davis
"Be-ing Without Clothes," Massachusetts Institute of Technology, Cambridge

1971 "Visual Dialogue Foundation," Friends of Photography, Carmel, California

1972 "Photographic Portraits," Moore College of Art, Philadelphia
"Photographs of Women," Museum of Modern Art, New York [No catalogue]

1973 "Sixties Continuum," International Museum of Photography at George Eastman House,
Rochester, New York (No catalogue)

1974 "Photography in America," Whitney Museum of American Art, New York
"Private Realities," Museum of Fine Arts, Boston

1975 "Women of Photography," San Francisco Museum of Art, San Francisco

1976 "U.C.L.A. Collection of Contemporary American Photographs," Fredrick S. Wight Art
Gallery, University of California, Los Angeles
"Contemporary Trends," Columbia College, Chicago

1977 "Great West: Real/Ideal," University of Colorado, Boulder

1978 "Mirrors and Windows," Museum of Modern Art, New York
"Tusen och en bild," Fotografiska Museet, Moderna Museet, Stockholm

1979 "Photographie als Kunst, 1879–1979," Tiroler Landesmuseum, Innsbruck
"Attitudes: Photography in the 1970's," Santa Barbara Museum of Art, Santa Barbara,
California

1981 "Portrait Styles: Judy Dater and Her Predecessors," Catskill Center for Photography,
Woodstock, New York (No catalogue)
"Photo Facts and Opinions," Addison Gallery of American Art, Phillips Academy,
Andover, Massachusetts [Catalogue with text but no photographs]

1982 "California Photography," Rhode Island School of Design, Providence

1983 "The Arranged Image," Boise Gallery of Art, Boise, Idaho
"Printed by Women," Port of History Museum, Philadelphia

1984 "Pushing the Boundaries: Photography in California, 1945–1980," San Francisco
Museum of Modern Art, San Francisco
"The Nude in Photography," Stadtmuseum, Munich
"La Photographie Créative: Les Collections de Photographies Contemporaines de la
Bibliothèque Nationale," Bibliothèque Nationale, Paris

1985 "This Is Not About the Artist's Ego: Some Political Photographs of the 1980's," Artemisia
Gallery, Chicago [No catalogue]
"A Women's Show," Photographer's Gallery, Palo Alto, California [No catalogue]

SELECTED PERMANENT COLLECTIONS

Art Institute of Chicago
Bibliothèque Nationale, Paris
Center for Creative Photography, Tucson, Arizona
Detroit Institute of Arts
International Center of Photography, New York
International Museum of Photography at George Eastman House, Rochester, New York
Kinsey Institute for Sex Research, Indiana University, Bloomington
Library of Congress, Washington, D.C.
Metropolitan Museum of Art, New York
Moderna Museet, Stockholm
Museum of Fine Arts, Boston
Museum of Modern Art, New York
Oakland Museum, Oakland, California
San Francisco Museum of Modern Art
Seattle Art Museum
Yale University Art Gallery, New Haven, Connecticut

DESIGNED BY LINNEA GENTRY SHEEHAN
COMPOSED BY TYPECRAFT
PRINTED BY FABE LITHO, LTD.
BOUND BY ROSWELL BOOKBINDING